PARIS

City Highlights

teNeues

Imprint

Texts: Yasemin Erdem
Service: Marianne Bongartz, MaBo-Media, Cologne
Translations: Alphagriese Fachübersetzungen, Dusseldorf; Susanne Olbrich (Service)
Editorial management: Hanna Martin, Susanne Olbrich
Layout: Anne Dörte Schmidt
Imaging and Pre-press: Jan Hausberg, Martin Herterich

Photo credits: Matthias Just, beside: Roland Bauer (pp. 5 t. r., 69, 70–71, 74–75, 80–85, 112–121, 124–133, Backcover l.); Le Bon Marché Rive Gauche (pp. 100–101); Cité de la Musique (p. 64); courtesy of Colette (pp. 102–103); courtesy of Fondation Le Corbusier / Bildkunst (pp. 60–61); Pep Escoda (S. 5 t. l., 11 t. l., 78–79); Christophe Fouin und © ADAGP / Bildkunst, Paris 2006, Photothèque du Musée de la Ville de Paris (p. 56, Artist: Douglas Gordon; p. 57, Artist: Jean Michel Othoniel); Michelle Galindo (pp. 30–31, 52 t. l., 155 t. l.); Matthias Just / Bildkunst (pp. 40, 46–47); Martin Nicholas Kunz (pp. 3, 4 t. r.); © Musée d'Orsay / Sophie Boegly and © Musée d'Orsay / Patrice Schmidt (pp. 50–51); Architect: Jean Nouvel (p. 40 Institut du Monde Arabe, pp. 52–53 Musée Quai Branly); Patricia Parinejad (pp. 122–123); Francis Peyrat (pp. 92–93); Sabine Scholz (p. 19); Architekt Johan Otto von Spreckelsen (pp. 38–39 La Grande Arche)
Cover: Martin Nicholas Kunz

Content and production: fusion publishing GmbH, Stuttgart . Los Angeles
www.fusion-publishing.com

teNeues Publishing Group

teNeues Verlag GmbH + Co. KG
Am Selder 37
47906 Kempen, Germany
Tel.: 0049 / (0)2152 / 916 0
Fax: 0049 / (0)2152 / 916 111

teNeues Publishing Company
16 West 22nd Street
New York, NY 10010, USA
Tel.: 001-212-627-9090
Fax: 001-212-627-9511

teNeues Publishing UK Ltd.
P.O. Box 402
West Byfleet, KT14 7ZF
Great Britain
Tel.: 0044-1932-403509
Fax: 0044-1932-403514

teNeues France S.A.R.L.
93, rue Bannier
45000 Orléans, France
Tel.: 0033-2-38541071
Fax: 0033-2-38625340

Press department: arehn@teneues.de
Tel.: 0049 / (0)2152 / 916 202

www.teneues.com

© 2007 teNeues Verlag GmbH & Co. KG, Kempen

Copy deadline: 1 February 2007

Bibliographic information published by Die Deutsche Bibliothek. Die Deutsche Bibliothek lists this publication in the Deutsche Nationalbibliografie; detailed bibliographic data is available in the Internet at http://dnb.ddb.de.

ISBN 978-3-8327-9195-7

Printed in Italy

Right page:
View of the Eiffel Tower from Trocadéro

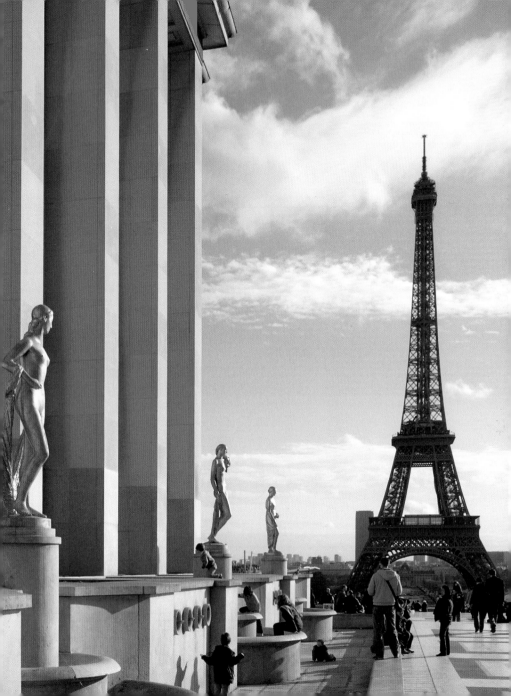

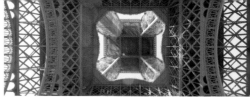

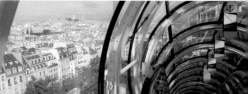

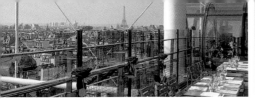

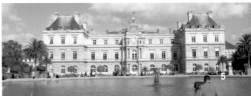

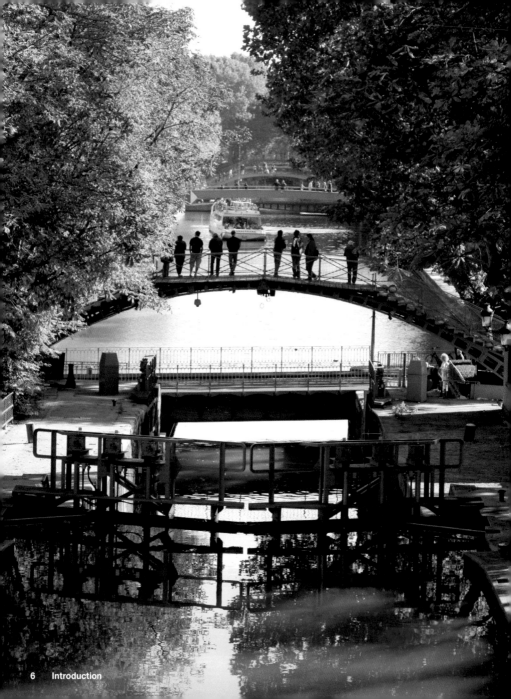

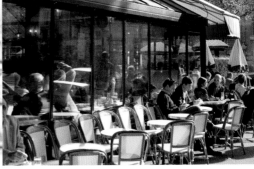

Left page: Canal St-Martin
Right page: Left entrance to the Metro, right café in the Latin Quarter

Stay a While...

The city of love is also the city of the big gestures, exorbitance, gallantry, chansons, good food—and it is always very stylish. Paris' grand past is everywhere. The self-confidence of the city remains unclouded to this day. Pompous, elegant structures and broad boulevards testify to the aristocracy. Often seen as the stronghold for romantics, this city also radiates something dark, almost morbid, despite all of its esthetic aspects. There is hardly another place in the world where the present moment can be celebrated like here. Some parts of the city seem like a film set, and Paris appears to have something cinematic, almost unreal about it. Like a capricious seductress who constantly changes, promises much, and yet gives no guarantee of anything. Almost like an evil spirit, Paris draws visitors under its spell, provokes joyful anticipation of the moment, celebrates the present, and then loses interest again. *C'est la vie.* It probably isn't a coincidence that many love stories start here—or also come to an end—and this may just be in films, but they often reflect reality. Perhaps it is because this city is so lovely, almost intolerably beautiful, and reminds its visitors how transient everything is. There is a good reason why Bernardo Bertolucci's film *The Last Tango in Paris* is set in this incomparable city.

Left page: Left Place des Vosges, right Bois de Boulogne
Right page: Café in the Latin Quarter

« Reste encore un peu … »

La ville de l'amour est aussi la ville des grands gestes, de la démesure, de la galanterie, des chansons et de la bonne cuisine – et surtout, elle a toujours du style. Le passé majestueux de Paris est omniprésent, rien n'a encore entamé son assurance. Un air d'aristocrate se reflète dans les bâtiments somptueux et élégants et les larges boulevards. Souvent considérée comme le bastion des romantiques, cette ville, avec tous ses côtés esthétiques, a aussi quelque chose de sombre, presque morbide. On peut y célébrer l'instant comme nulle part ailleurs: certains quartiers ressemblent à des décors de cinéma et Paris a quelque chose de cinématographique, presque irréel. Comme une séduc-trice capricieuse qui change toujours, promet beaucoup, mais ne donne jamais de garantie. Presque comme un démon, Paris envoûte ses visiteurs, provoque une joie anticipée, célèbre l'instant et puis ne s'en soucie plus. *C'est la vie.* Ce n'est probablement pas par hasard que beaucoup d'histoires d'amour commencent – ou finissent ici – ne serait-ce que dans les films, qui reflètent souvent la réalité. Peut-être cette ville est-elle si belle qu'elle en est presque in-supportable, et qu'elle rappelle à ses visiteurs le caractère éphémère de toutes choses. Ce n'est pas fortuit que le film de Bernardo Bertolucci « Le dernier tango à Paris » joue dans cette ville incomparable.

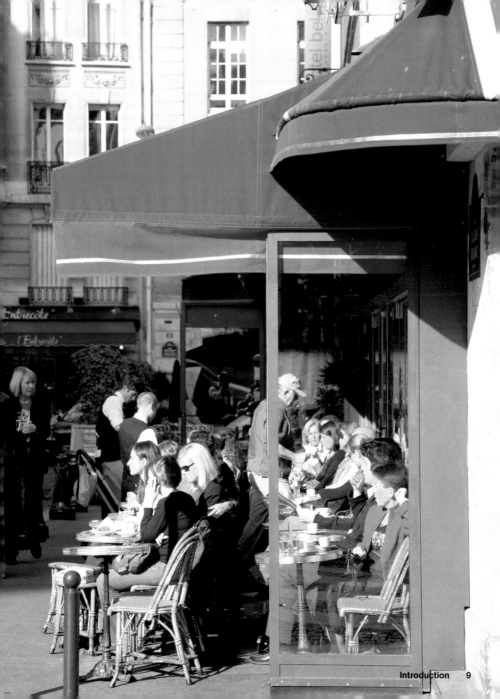

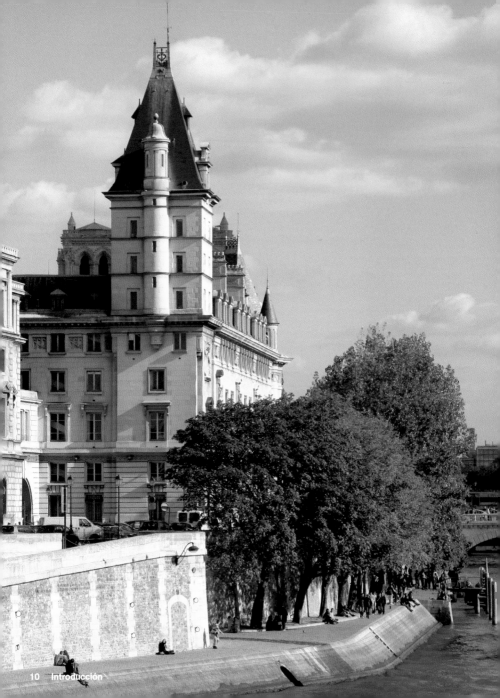

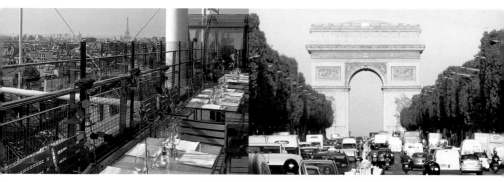

Left page: Palais de Justice
Right page: Left Chez Georges inside the Pompidou Center, right Champs-Elysées with Arc de Triomphe

Ay, instante eterno …

La ciudad del amor es también la ciudad de los grandes gestos, de los excesos, de las canciones y de la buena cocina, todo ello cargado de estilo. El pasado señorial y noble de París continúa siendo omnipresente y el orgullo de la ciudad permanece intacto. Las construcciones elegantes y fastuosas y sus amplias avenidas están impregnadas de aristocracia. Si bien París ha sido considerada a menudo baluarte del romanticismo, aún con todos sus lados estéticos desprende un toque oscuro, casi mórbido. Aquí, es posible disfrutar del instante eterno, como quizás en ningún otro lugar del mundo. Algunos de sus barrios parecen escenarios de película, y efectivamente, París posee un encanto cinematográfico, casi irreal. Como una dama seductora y caprichosa y cambiante promete mucho, pero nunca da garantías. La ciudad casi demoníaca atrae el visitante en su maldición, provocándole una alegría anticipada, recreándose en el instante sin preocuparse del después. C'est la vie. No será por casualidad que aquí comiencen muchas historias de amor y otras terminen. O ya sea en el cine, que a menudo refleja la realidad. Quizás sea su belleza intensa, casi insoportable, recordando al visitante lo fugaz y pasajero que es todo. De ahí que el "Último Tango" de Bernardo Bertolucci se bailara en París.

Left page: Left Moulin Rouge, right shop in the Latin Quarter
Right page: Rue Norvins, Montmartre

O attimo fuggente ...

La città dell'amore è anche la città dei grandi gesti, degli eccessi, della galanteria, delle chansons, del buon cibo — sempre con inesauribile stile. Il passato signorile di Parigi è onnipresente, la sua consapevolezza di sé è ancora intatta, i pomposi ed eleganti edifici e gli ampi boulevard ne testimoniano l'aristocrazia. Spesso considerata la roccaforte del romanticismo, pur in tutta la sua bellezza, questa città evoca anche qualcosa di oscuro, quasi di morboso. Qui si può assaporare l'attimo fuggente come forse in nessun altro luogo al mondo. Alcuni quartieri somigliano allo scenario di un film, ed effettivamente Parigi possiede qualcosa di cinematografico, di pressoché irreale, come una seduttrice capricciosa, sempre mutevole, che promette molto senza garantire nulla. Al pari di un demonio, Parigi ammalia il visitatore, provoca in lui una subitanea anticipazione di gioia, gode dell'attimo senza preoccuparsi del poi. C'est la vie. Non è un caso, probabilmente, se molte storie d'amore hanno proprio qui il loro inizio — o la loro fine —, anche se solo in un film che, comunque, spesso rispecchia la realtà. Sarà perché Parigi è così insopportabilmente bella che chi la visita non può fare a meno di ricordare come tutto sia effimero. E non a caso anche "l' Ultimo Tango a Parigi", il film di Bernardo Bertolucci, è stato danzato in questa città senza eguali.

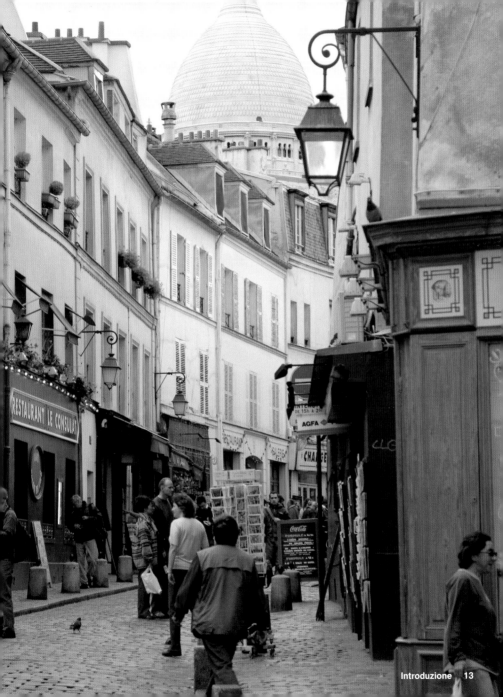

Sightseeing

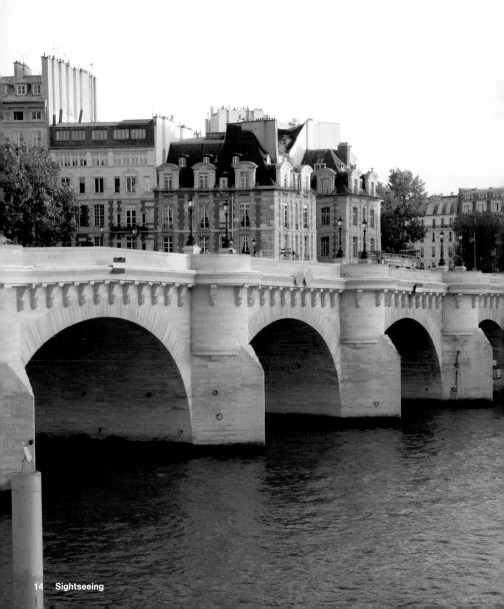

The glass pyramid at the inner court of the Louvre is a symbol of the city's transformation. In Paris, which already was a place for cultural and architectural experiments during the age of the kings, the old harmonizes with the new. After the revolution, large boulevards and stately rows of houses were designed. Today, the presidents put their stamp on the city with innovative building projects like the Centre Pompidou or the Grande Arche.

La pyramide en verre dans la cour intérieure du Louvre est le symbole de la mutation de la ville. A Paris, qui était déjà un terrain propice aux expériences culturelles et architecturales au temps des rois, le nouveau s'harmonise avec l'ancien. Après la Révolution, de grands boulevards et d'imposantes rangées de maisons ont été construits. Aujourd'hui, ce sont les présidents qui laissent leur empreinte dans la ville avec de grands travaux innovateurs comme le Centre Pompidou ou la Grande Arche.

La pirámide de cristal en el corazón del Louvre simboliza la transformación de la ciudad. En París, campo de experimentos culturales y arquitectónicos desde los tiempos de la realeza, lo nuevo y lo antiguo conviven en plena armonía. Tras la Revolución se crearon amplias avenidas y majestuosos edificios estatales; hoy en día, son los Jefes de Estado quienes dejan su huella en la ciudad, con construcciones innovadoras como el Centro Pompidou, o el Grande Arche.

La piramide di vetro all'interno del Louvre simboleggia il cambiamento della città. Fin dai tempi della monarchia, Parigi è stata teatro di esperimenti architettonici e culturali, in cui il vecchio si armonizza con il nuovo. Dopo la Rivoluzione sono sorti grandi boulevard e file di imponenti palazzi; oggi sono i Capi di Stato che, con costruzioni innovative come il Centro Pompidou o la Grande Arche, caratterizzano l'aspetto della città.

Left page: Pont-Neuf, **right page:** Left Place Vendôme, right arcades at the Place des Vosges

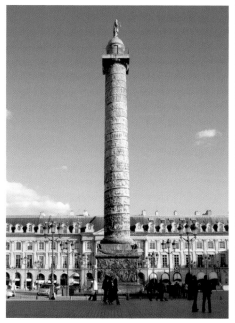

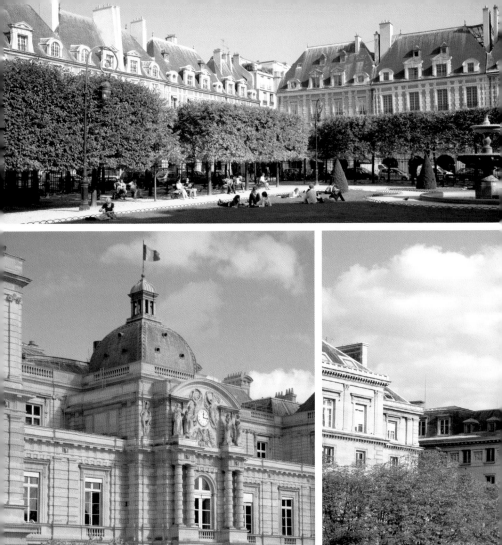

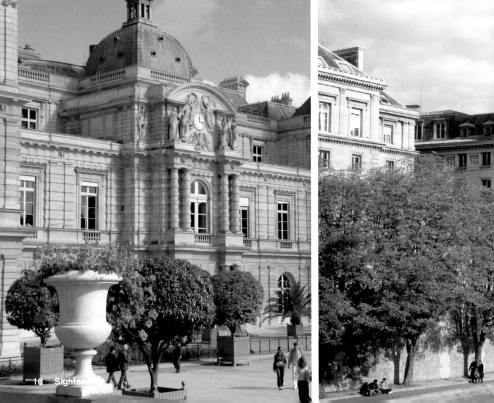

Left page: Top Place des Vosges, bottom Palais du Luxembourg
Right page: Top Place du Tertre, Montmartre, bottom Palais de Justice

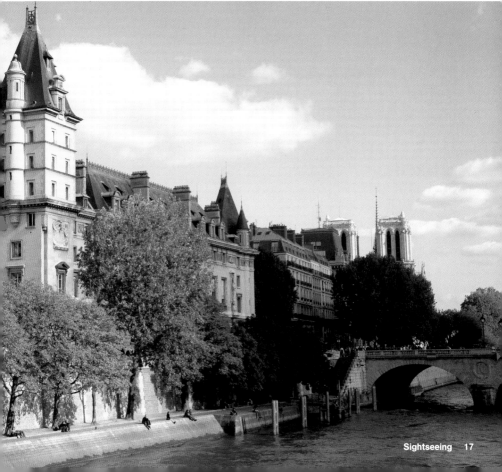

Arc de Triomphe

Place Charles-de-Gaulle
75008 Paris
8e Arrondissement
Phone: +33 / 155 37 73 77
www.monum.fr
www.parismuseumpass.fr

Opening hours: April–Sept daily 10 am to 11 pm, Oct–March daily 10 am to 10.30 pm; closed in the morning on 1st Jan, 1st May, 8th May, 14th July, 11th Nov and closed all day on 25th Dec
Admission: From € 5, free for disabled people and those who purchased the Paris Museum Pass
Metro station: Charles de Gaulle - Etoile
Map: No. 1

 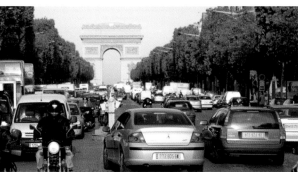

The structure based on the triumphal arches of Roman antiquity honors the French Army with its reliefs and commemorates Napoleon's battles and victories. Inside, a museum documents France's military history. If you do not mind the climb to the observation platform, you will enjoy a magnificent view of Paris.

Ce monument qui s'inspire des arcs de triomphe de l'antiquité romaine rend hommage à l'armée française avec ses reliefs, et rappelle les batailles et victoires de Napoléon. A l'intérieur, un musée informe sur l'histoire militaire de la France. Celui qui ne craint pas de monter sur la plate-forme découvre une vue magnifique sur Paris.

Esta construcción inspirada en los antiguos arcos romanos honra en sus bajorrelieves al ejército francés recordando las batallas y las victorias de Napoleón. En el interior, el museo recorre la historia militar de Francia. Quien no tenga miedo a las alturas será recompensado por la magnífica vista de París desde la plataforma panorámica.

La costruzione, ispirata agli archi di trionfo romani, onora nei suoi bassorilievi l'esercito francese e ricorda le battaglie e le vittorie napoleoniche. All'interno, un museo racconta la storia militare di Francia. Chi se la sente, può salire sulla piattaforma panoramica e godere da lassù di una fantastica vista su Parigi.

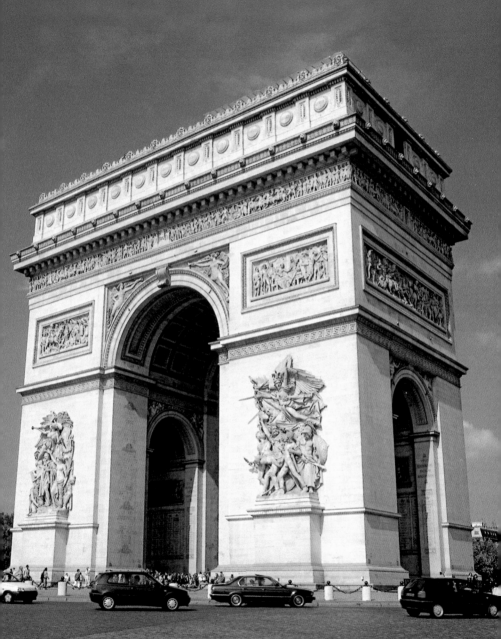

Champs-Elysées

Avenue des Champs-Elysées
75008 Paris
8e Arrondissement

Metro station: Franklin D. Roosevelt, Champs-Elysées - Clemenceau
Map: No. 8

On this avenue, the epitome of a splendid boulevard, you will find many luxury stores and grand structures such as the Grand Palais, the Petit Palais, and the Elysée Palace, which is the official residence of the French President. This is where France celebrates its national holiday or rejoices when the Tour de France participants reach their goal.

Sur cette avenue, la grande avenue par excellence, on trouve de nombreux magasins de luxe et des monuments magnifiques comme le Grand Palais, le Petit Palais et le Palais de l'Elysée, la résidence officielle des présidents français. C'est ici que les Français s'auto-célèbrent le jour de la fête nationale et acclament les coureurs du Tour de France arrivant au but.

En esta avenida, personificación de la magnificencia, se encuentran numerosas tiendas de lujo, además de grandiosas construcciones como el Grand y el Petit Palais y el Elysée, sede de la Presidencia de la República. Aquí, el país celebra las fiestas nacionales y saluda a los participantes del Tour de Francia en su llegada a la meta final.

In questa magnifica strada si trovano numerosi negozi di lusso e imponenti costruzioni come il Grand Palais, il Petit Palais e l'Eliseo, sede del Presidente della Repubblica francese. Qui si celebrano le festività nazionali e si salutano i partecipanti del Tour de France al loro traguardo finale.

Place de la Concorde

Place de la Concorde
75008 Paris
8e Arrondissement
www.insecula.com

Metro station: Concorde
Map: No. 51

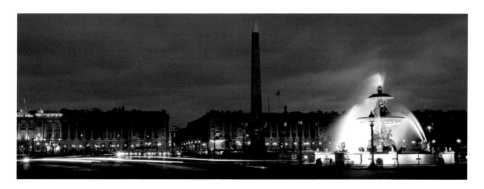

Designed in the mid-18th century in honor of Louis XV, the square soon had a new, bloody purpose: During the Revolution, the guillotine replaced the equestrian statue of the king. Since 1836, an obelisk from Luxor that is 75 ft tall and weighs 230 t towers above the spacious grounds, adding a majestic flair to the square.

Aménagée au milieu du XVIIIe siècle en l'honneur de Louis XV, la place eut bientôt une nouvelle fonction sanglante : pendant la Révolution, la guillotine remplaça la statue du roi chevalier. Depuis 1836, un obélisque de Louxor mesurant 23 m de haut et pesant 230 t, domine cette immense place et lui confère un aspect particulièrement majestueux.

Creada a mediados del siglo XVIII para conmemorar a Luis XV, pronto la plaza encontró un uso más macabro: durante la Revolución la estatua ecuestre del rey fue sustituida por la guillotina. Desde 1836 la zona está dominada por un obelisco de 23 metros de altura y 230 toneladas de peso procedente de Luxor que le confiere un aire aún más majestuoso.

Realizzata alla metà del XVIII secolo in onore di Luigi XV, diventò presto teatro di un nuovo e sanguinoso rituale: durante la Rivoluzione, la statua equestre del re fu sostituita dalla ghigliottina. Dal 1836, un obelisco alto 23 metri e pesante 230 tonnellate, proveniente da Luxor, domina la piazza, conferendole una maestosità particolare.

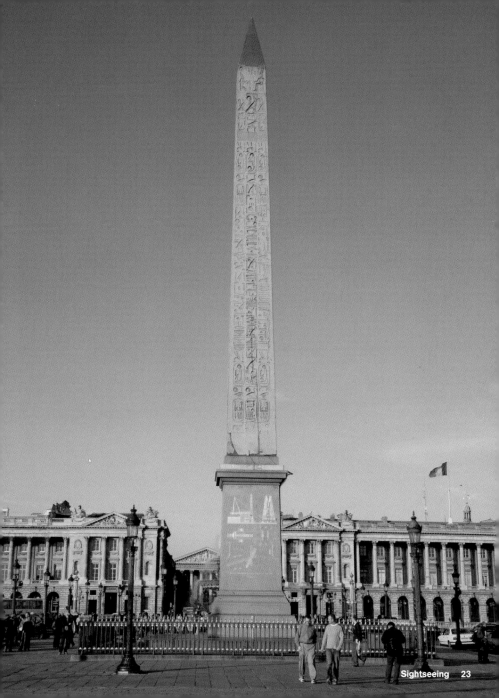

Notre-Dame

Ile de la Cité
6, place du Parvis-Notre-Dame
75004 Paris
4e Arrondissement
Phone: +33 / 142 34 56 10
www.cathedraledeparis.com

Opening hours: Daily 7.45 am to 6.45 pm; guided tours in English Wed+Thu 2 pm, Sat 2.30 pm; touring the cathedral towers 9.30 am to 7.30 pm all 10 min.
Admission: € 7.50, concessions € 4.80, groups € 5.70
Metro station: Cité, St-Michel - Notre-Dame
Map: No. 48
Editor's tip: When you cross the Pont St-Louis you will arrive at "Berthillon". The best ice-cream makers in the city (Wed–Sun, 31, rue St-Louis-en-Ile).

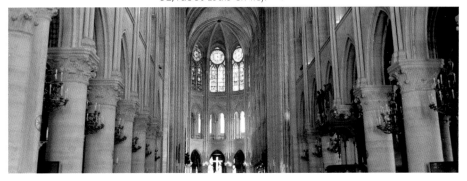

The west façade of the Gothic gem that dominates the Ile de la Cité was built between 1163 and 1345. It impresses the visitor with its richly decorated portal and gallery of Old Testament kings. The interior of the cathedral is primarily illuminated by a splendid rose window, the largest one ever built in the Middle Ages with a diameter of 42 ft.

La façade ouest de ce trésor gothique, édifiée entre 1163 et 1345 et dominant l'Ile de la Cité, impressionne avec son portail richement décoré et la galerie des rois de l'Ancien Testament. L'intérieur de la cathédrale est surtout éclairé par la magnifique rosette vitrée, la plus grande du Moyen-Âge avec ses 13 m de diamètre.

Joya de la arquitectura gótica, construida entre 1163 y 1345, Notre-Dame reina sobre la Île de la Cité e impresiona por su pórtico ricamente decorado en el lado occidental y por la galería de los Reyes del Antiguo Testamento. El interior de la catedral recibe la máxima luz a través de su magnífico rosetón medieval, de 13 metros de diámetro.

Gioiello dell'architettura gotica, eretta tra il 1163 e il 1345, Notre-Dame si erge sull'Île de la Cité; il portale riccamente ornato della facciata occidentale e la galleria dei Re dell'Antico Testamento sono notevolissimi. L'interno della cattedrale riceve luce attraverso il magnifico rosone medievale del diametro di 13 metri.

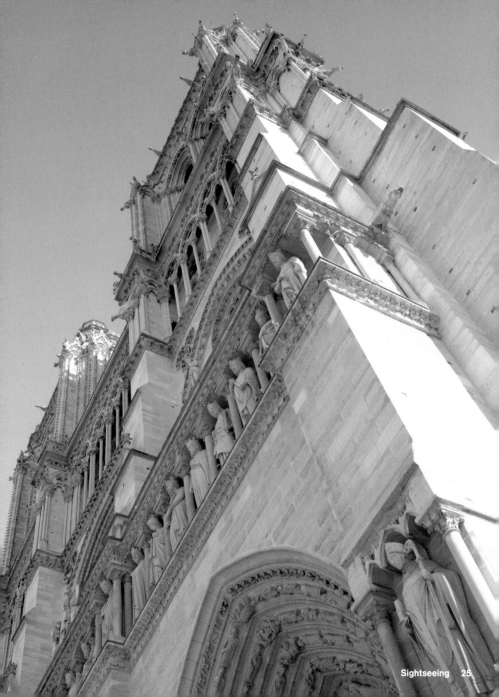

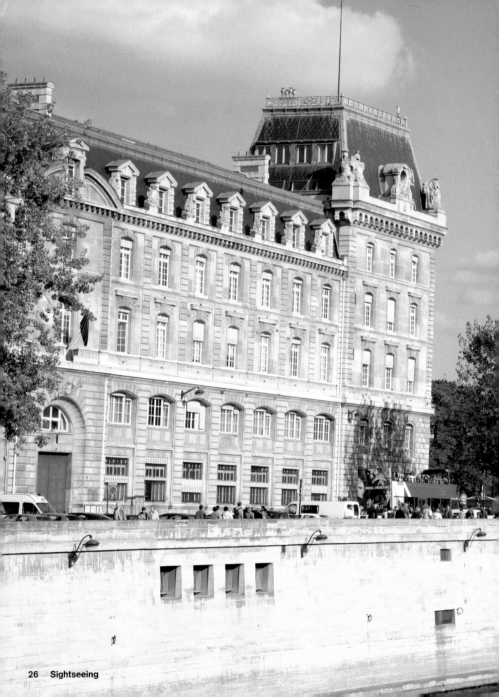

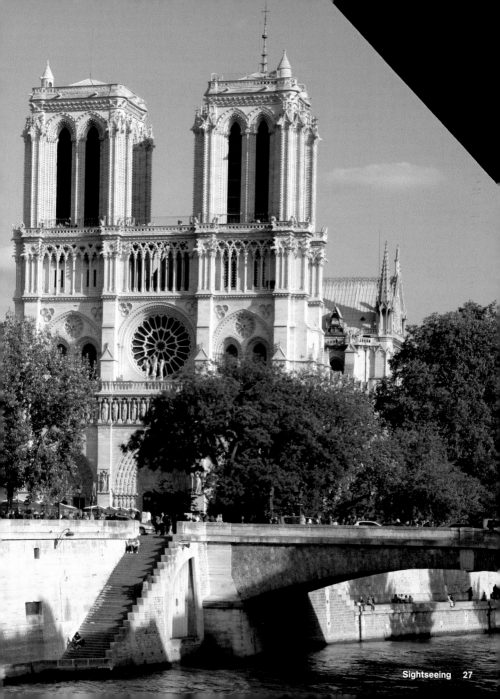

...lle

Opening hours: Nov–Feb daily 9 am to 5 pm, March–Oct daily 9.30 am to 6 pm; closed on 1st Jan, 1st May and 25th Dec
Admission: € 5.50, concessions € 3.50, groups € 4.50; free with the Paris Museum Pass
Metro station: Cité
Map: No. 55

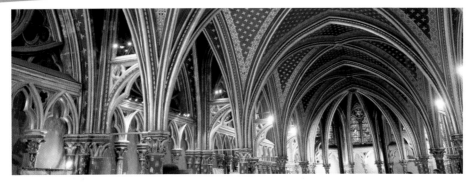

This jewel of High Gothic architecture, presumably erected between 1239 and 1248 at the request of King Louis IX, was built for the safekeeping of the Passion relics (Christ's crown of thorns and parts of the cross). The impressive character is due to its colorful lower chapel and the fragile beauty of its upper chapel, which appears to be made completely of transparency and color.

Ce joyau du gothique rayonnant, probablement édifié entre 1239 et 1248 à la demande du roi Louis IX pour la conservation des reliques de la passion (la couronne d'épines du Christ et des parties de la croix), est impressionnant avec sa chapelle basse colorée et la beauté fragile de la chapelle haute, remarquable de couleur et de transparence.

Esta obra maestra perteneciente al alto gótico, presumiblemente construida entre 1239 y 1248 bajo el reinado de Luis IX para custodiar las reliquias de la pasión de Cristo (la corona de espinas y una parte de la cruz), impacta por los vivos colores de la capilla inferior y la frágil belleza de su parte superior, que parece estar constituida sólo por colores y transparencias.

Capolavoro dell'alto-gotico, fu costruita presumibilmente tra il 1239 e il 1248 per volere di Luigi IX per custodire le reliquie della passione di Cristo (la corona di spine e parte della croce). È degna di nota per la cappella inferiore, dai colori sgargianti, e per la delicata bellezza della parte superiore, che sembra reggersi esclusivamente sui colori e sulle trasparenze.

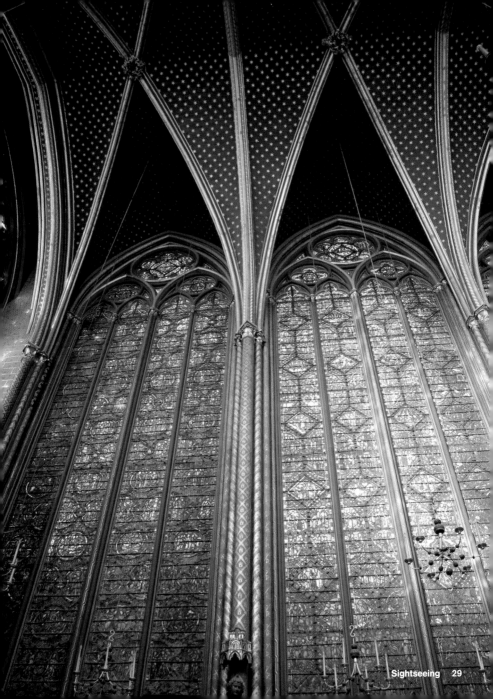

Eiffel Tower

Champ-de-Mars
75007 Paris
7e Arrondissement
Phone: +33 / 144 11 23 23
www.tour-eiffel.fr

Opening hours: Jan–15th June and Sept–Dec 9.30 am to 11.45 pm (elevator), 9.30 am to 6.30 pm (stairway); 16th Jun–Aug 9 am to 12.45 am (elevator + stairway)
Prices: Elevator € 4.20, € 7.70 + € 11 stairway, children € 3.80
Metro station: Bir-Hakeim, Champ de Mars - Tour Eiffel, Ecole Militaire
Map: No. 18
Editor's tip: To avoid the line walk up the stairway to the first platform and continue your way via the elevator.

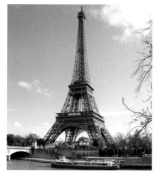

The Eiffel Tower—created by Alexandre Gustave Eiffel (1832 to 1923) on the occasion of the French Revolution's centennial and the Paris World Exhibition in 1889—has become a symbol for France throughout the world. The view from the platforms of the 986-foot tall "Iron Lady" is breathtaking.

La Tour Eiffel – créée par Alexandre Gustave Eiffel (1832 à 1923) à l'occasion du centenaire de la Révolution et de l'exposition universelle de Paris en 1889 – est devenue le symbole de la France dans le monde entier. La vue du haut des 300 m de « la dame de fer » avec ses plates-formes est sublime.

Fue erigida en el año 1889 por Alexandre Gustave Eiffel (1832 – 1923) para conmemorar del centenario de la Revolución Francesa y de la Exposición Mundial de París. Así la Torre Eiffel se ha convertido en el símbolo de Francia en todo el mundo. La vista desde las plataformas de la "Dama de Hierro", con una altura de 300 metros, es sobrecogedora.

Realizzata nel 1889 da Alexandre Gustave Eiffel (1832 – 1923) in occasione del centenario della Rivoluzione Francese e dell'Esposizione Mondiale di Parigi, la Torre per eccellenza è diventata il simbolo della Francia nel mondo intero. La vista che si gode dalle piattaforme della "Dama di Ferro", alta 300 metri, è sbalorditiva.

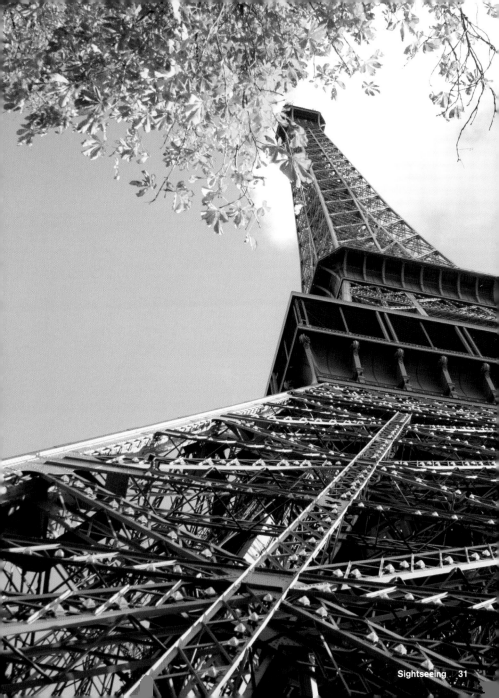

Hôtel des Invalides and chapel dome

129, rue de Grenelle
75007 Paris
7e Arrondissement
Phone: +33 / 144 42 38 77
www.invalides.org
www.parismuseumpass.fr

Opening hours: Oct–March daily 10 am to 5 pm, April–Sept daily 10 am to 6 pm; closed on the first Mon in the month, and also on 1st Jan, 1st May, 1st Nov and 25th Dec
Admission: € 8, concessions € 6, groups € 4, free children (18 and under), audio guides € 1, free with the Paris Museum Pass
Metro station: La Tour-Maubourg, Varenne
Map: No. 26

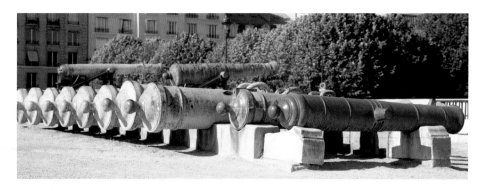

Louis XIV commissioned the ornate complex of buildings of the Hôtel des Invalides with the dominating cathedral. It was completed in 1735. This monumental Baroque structure with its imposing golden dome was intended as the final resting place for the Sun King. However, the first French emperor, Napoléon Bonaparte, was laid to rest here in 1840.

C'est Louis XIV qui commanda ce superbe complexe de l'Hôtel des Invalides avec son dôme le surplombant. Il fut achevé en 1735. Cette construction monumentale entre baroque et classique avec l'impressionnant dôme doré devait être la dernière demeure du Roi Soleil. Mais finalement, c'est le premier empereur français Napoléon Bonaparte qui y fut inhumé en 1840.

Luis XIV asignó una función concreta al ostentoso complejo del Hôtel des Invalides, dominado por la catedral y finalizado en el año 1735. Este monumento barroco-neoclásico, con una imponente cúpula dorada, fue creado para acoger los restos mortales del Rey Sol. Sin embargo es el primer emperador francés, Napoleón Bonaparte, quien aquí descansa desde 1840.

Fu Luigi XIV a ordinare la costruzione del pomposo complesso dell'Hôtel des Invalides, dominato dal duomo e terminato nel 1735. Questo monumento in stile barocco-neoclassico, con la sua imponente cupola dorata, avrebbe dovuto accogliere i resti mortali del Re Sole. Nel 1840, invece, vi fu sepolto il primo imperatore francese, Napoleone Bonaparte.

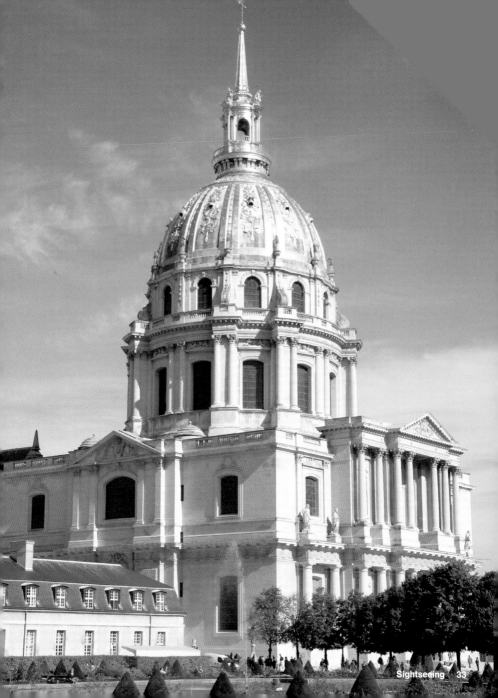

Metro station: St-Paul
Map: No. 33
Editor's tip: Le Marais is these days the area where you can find the most outlandish boutiques and galleries, no matter if you are looking for funky fashion, contemporary art or eccentric souvenirs.

Situated in the heart of the city, this quarter with its splendid city palaces and crooked workers' houses radiates lots of original atmosphere. It is the historic center of Jewish life in Paris. Place des Vosges, possibly the most beautiful square in the city, is located here.

Situé au cœur de la ville, ce quartier original, avec ses magnifiques palais urbains et ateliers d'artisans de guingois, dégage une atmosphère particulière. C'est le centre historique de la communauté juive de Paris, avec peut-être la plus belle place de la ville, la Place des Vosges.

Este barrio de aire original ubicado en el corazón de la ciudad transmite una atmósfera muy especial con sus suntuosos palacios construidos junto a edificios artesanales de formas inclinadas. Se trata del centro tradicional de la comunidad judía de París, e incluye la Place des Vosges, tal vez la plaza más bella de la ciudad.

Situato nel cuore della città, questo quartiere dal carattere originale sprigiona, con i suoi sontuosi palazzi e le sghembe abitazioni degli artigiani, un'atmosfera assai particolare. È il tradizionale centro della comunità ebraica di Parigi, e racchiude quella che è forse la più bella piazza della città, la Place des Vosges.

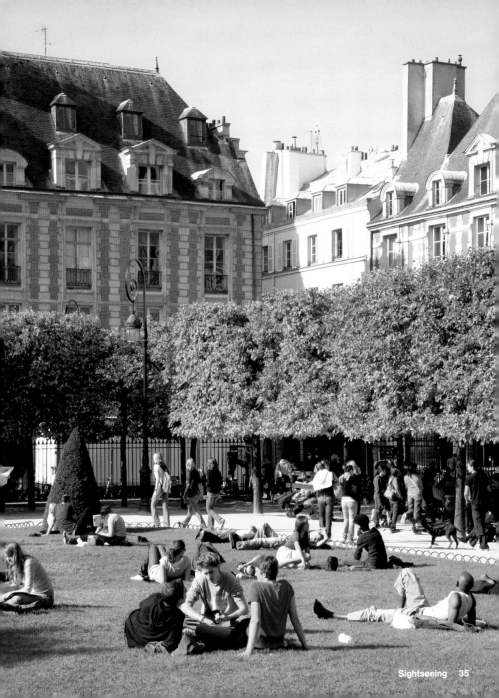

Sacré-Cœur

35, rue du Chevalier-de-la-Barre
75018 Paris
18e Arrondissement
Phone: +33 / 153 41 89 00
www.sacre-coeur-
montmartre.com

Opening hours: Daily 6 am to 11 pm
Admission: Free
Metro station: Abbesses, Anvers, Lamarck - Caulaincourt
Map: No. 54

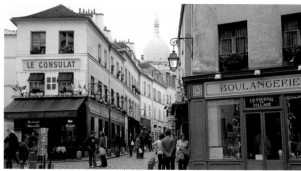

The Montmartre hill is crowned by the radiant white Sacré-Cœur church, which can be seen from a great distance. Its construction began in 1875 according to plans of the architect Paul Abadie, inspired by the Romano-Byzantine style of the Hagia Sophia and Saint Mark's Basilica. In the 19th century, Montmartre attracted many artists and literary figures who lived and worked here.

La colline de Montmartre est couronnée par la basilique du Sacré-Cœur, d'un blanc lumineux visible de loin, qui fut érigée à partir de 1875 suivant les plans de l'architecte Paul Abadie et inspirée du style roman-byzantin de la Hagia Sofia et de la basilique Saint-Marc. Au XIXe siècle, Montmartre attirait beaucoup d'artistes et d'écrivains qui vivaient et travaillaient là.

La colina de Montmartre está coronada por la Iglesia del Sagrado Corazón, bien visible desde lejos gracias a su color blanco resplandeciente. Fue construida en 1875 según los planes del arquitecto Paul Abadie, e inspirada en el estilo románico-bizantino de la Hagia Sofía y de la catedral de San Marcos. En el siglo XIX, Montmartre fue el punto de atracción para numerosos artistas y literatos que comenzaron aquí a vivir y trabajar.

Il colle di Montmartre sovrasta la Chiesa del Sacro Cuore, ben visibile per il suo biancore. Essa fu eretta nel 1875 su progetto dell'architetto Paul Abadie, che si ispirò allo stile romanico-bizantino delle cattedrali di Hagia Sophia e di San Marco. Nell'Ottocento Montmartre fu meta di diversi artisti e letterati che qui vissero e lavorarono.

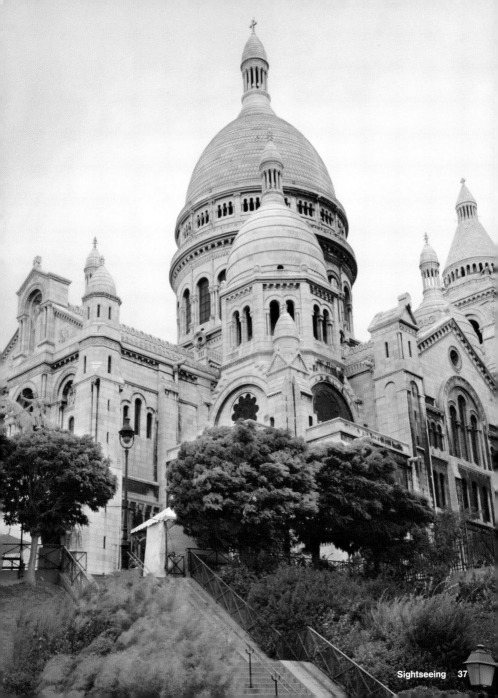

La Grande Arche

1, parvis de la Défense –
Paroi Nord – 35th floor
92044 Paris La Défense cedex
La Défense
Phone: +33 / 149 07 27 27
www.grandearche.com

Opening hours: April–Sept daily 10 am to 8 pm, Oct–March daily 10 am to 7 pm
Admission: Adults € 7.50, children (6 and under) free, teenagers and students € 6, discounted admission for families
Metro station: La Défense - Grande Arche
Map: No. 22
Special notes: Restaurant daily 11.30 am to 2.30 pm, observation platform

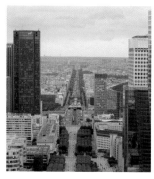
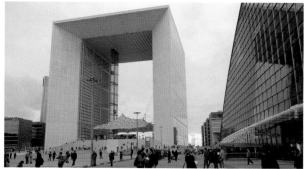

The futuristic triumphal arch of the architect Johan Otto von Spreckelsen in the La Défense suburb—a gigantic cube with a height of 364 ft and a width of 351 ft—was completed for the bicentennial of the French Revolution in 1989. It symbolizes a "window to the world—with a view of the future."

Ce nouvel arc de triomphe futuriste de l'architecte Johan Otto von Spreckelsen dans le quartier La Défense – un cube gigantesque d'une hauteur de 111 m et d'une largeur de 107 m – fut achevé pour le bicentenaire de la Révolution Française en 1989. Il symbolise « *une fenêtre sur le monde* – avec vue sur l'avenir ».

El nuevo y futurista Arco del Triunfo del arquitecto Johan Otto von Spreckelsen en la zona periférica de La Défense, un gigantesco cubo de 111 metros de alto y 107 de ancho, fue finalizado en 1989, con ocasión del bicentenario de la Revolución Francesa, y simboliza "una ventana hacia el mundo, con una mirada al futuro".

Il nuovo e futuristico arco di trionfo dell'architetto Johan Otto von Spreckelsen nel sobborgo La Défense – un gigantesco cubo alto 111 metri e largo 107 – venne approntato nel 1989, in occasione del bicentenario della Rivoluzione Francese. Esso simboleggia "una finestra sul mondo, con uno sguardo al futuro".

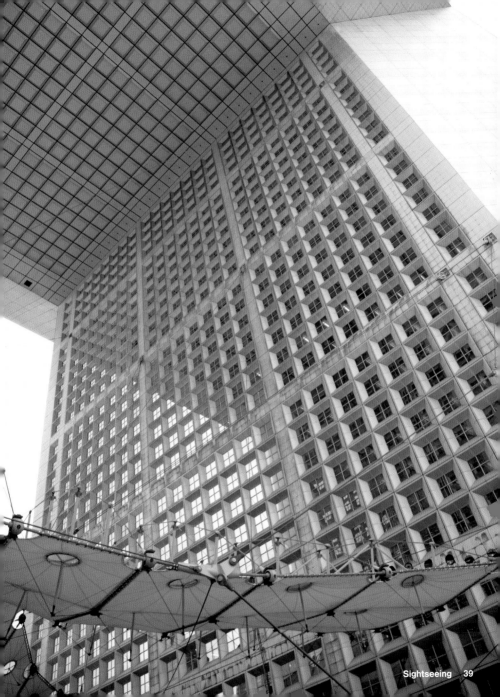

Culture
Museums Galleries Theaters Cinemas

معهد العالم العربي

institut du monde arabe

The cultural scene of Paris is so rich that you could never exhaust all of the possibilities. Up to 300 events take place every evening in places like the famous Comédie Française, the Opéra de la Bastille, one of the first-class jazz clubs, or variety theaters like the Moulin Rouge or Crazy Horse. Cineastes and museum enthusiasts will get their money's worth in Paris, as will connoisseurs of contemporary art.

L'offre culturelle à Paris est si riche qu'on ne peut jamais en épuiser toutes les possibilités. Chaque soir, il y a plus de 300 représentations, que ce soit à la célèbre Comédie Française, à l'Opéra Bastille, dans l'un des grands clubs de jazz ou dans des cabarets comme le Moulin Rouge ou le Crazy Horse. Pour autant, ni les cinéastes ni les amateurs de musées, ni même les connaisseurs de l'art jeune ne sont déçus à Paris.

La oferta cultural parisina es tan abundante que las posibilidades nunca se agotan. Cada noche tienen lugar en la ciudad más de 300 eventos; ya sean en la célebre Comédie Française, en la Opéra de la Bastille, en alguno de los refinados clubs de jazz, o en salas como el Moulin Rouge o el Crazy Horse. Cinéfilos, aficionados a los museos y especialistas en arte joven, encuentran también su lugar en París.

L'offerta culturale parigina è così ricca da risultare inesauribile. Ogni sera vi si tengono fino a 300 eventi: nella rinomata Comédie Française, nell'Opéra de la Bastille, oppure in uno dei sofisticati jazz club e varietà, come il Moulin Rouge o il Crazy Horse. Ma ci sono appuntamenti interessanti anche per i cineasti e gli appassionati di musei, nonché per gli amanti dell'arte giovane.

Left page: Institut du Monde Arabe
Right page: Left Opéra Garnier, right Pompidou Center

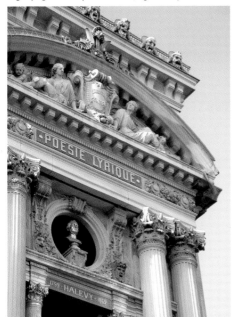

Musée du Louvre

75058 Paris Cedex 01
1er Arrondissement
Phone: +33 / 140 20 53 17
www.louvre.fr
www.parismuseumpass.fr

Opening hours: Mi–Mon 9 am to 6 pm, Wed+Fri to 10 pm;
closed on 1st Jan, 1st May and 25th Dec
Admission: € 8.50, from 6 pm to 10 pm € 6; free on the first Sun
of each month and with the Paris Museum Pass
Ticket service: Advance booking +33 / 140 13 49 13
Metro station: Palais-Royal - Musée du Louvre
Map: No. 40

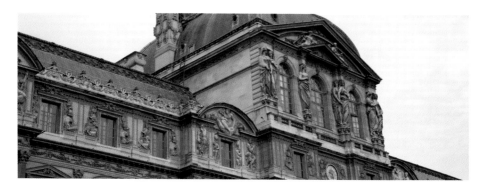

The former royal palace is the best-known and largest museum in the world. The glass pyramid of the architect I. M. Pei in the museum courtyard has served as the entrance since 1989. The Louvre provides space for more than 300,000 exhibits that include such internationally famous works as the *Mona Lisa* and *Venus de Milo*, as well as a world-class Egyptian department.

L'ancien palais du roi est le musée le plus grand et le plus connu au monde. La pyramide en verre de l'architecte I. M. Pei dans la cour du musée sert d'entrée depuis 1989. Le Louvre héberge plus de 300 000 pièces, dont des œuvres mondialement célèbres comme la « Mona Lisa » et la « Venus de Milo », ainsi qu'un département égyptien de niveau mondial.

El antiguo palacio real es el mayor y más famoso museo del mundo. La pirámide de cristal del arquitecto I. M. Pei en su patio sirve de entrada desde 1989. El museo expone más de 300 000 obras, algunas de las cuales son famosas en todo el mundo, como la *Mona Lisa* y la *Venus de Milo*, e incluye también una sección egipcia de nivel internacional.

L'ex palazzo reale è il museo più grande e famoso del mondo. La piramide di vetro dell'architetto I. M. Pei nel cortile del Museo funge da ingresso dal 1989. Il Louvre contiene oltre 300 000 pezzi da esposizione, tra cui opere celebri in tutto il mondo come la *Monna Lisa* e la *Venere di Milo*, oltre a una sezione egizia conosciuta a livello mondiale.

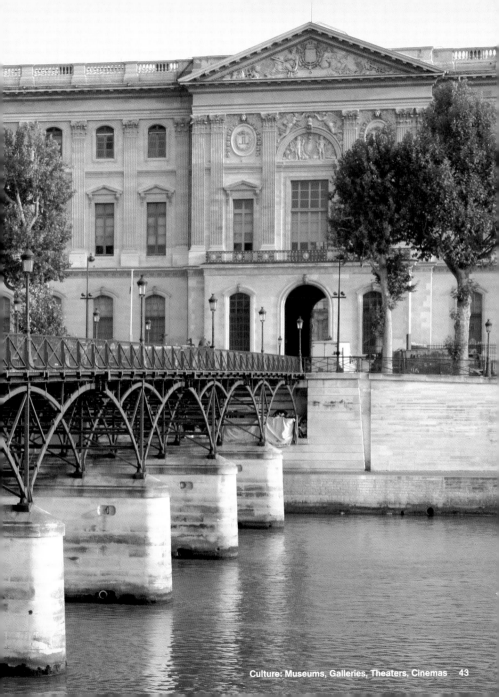

Centre d'Art et Culture Georges Pompidou

19, rue Beaubourg
75004 Paris
4e Arrondissement
Phone: +33 / 144 78 12 33
www.centrepompidou.fr
www.parismuseumpass.fr

Opening hours: Wed–Mon 11 am to 10 pm; closed on 1st May
Admission: "Ticket Musée & Expositions" € 10, valid for all current exhibitions, Espace 315 and the Children's gallery; children (6–18 years) free, but ticket required; children (6 and under) no ticket required; free with the Paris Museum Pass
Metro station: Rambuteau
Map: No. 7
Editor's tip: You will not find a better well-assorted arts bookstore or museum shop in Paris.

Built in the 1970s by Renzo Piano and Richard Rogers, the façade of this "culture factory" is characterized by a glass escalator and colorfully lacquered service pipes. The building contains the Musée d'art moderne with more than 56,000 works of art by more than 5,000 artists, representing all the great figures of the 20th century.

Erigé par Renzo Piano et Richard Rogers dans les années 70, ce « hangar de l'art » est caractérisé par une façade avec un escalier mécanique vitré et des tuyaux colorés. Le Musée d'Art Moderne qui s'y trouve abrite quelque 56 000 œuvres d'art de plus de 5 000 artistes, si bien que tous les grands du XXe siècle sont représentés.

La fachada de esta "fábrica de cultura", construida en los años 70 por Renzo Piano y Richard Rogers, está decorada con una escalera móvil acristalada y tubos de colores. En el Museo de Arte Moderno ubicado en el interior se pueden admirar más de 56 000 obras de 5 000 artistas entre los que figuran todos los grandes del siglo XX.

La facciata di questa "fabbrica di cultura", costruita negli anni 70 da Renzo Piano e Richard Rogers, è caratterizzata da una scala mobile vetrata e da tubi a colori vivaci. Nel Museo d'Arte Moderna qui ospitato sono esposte 56 000 opere di oltre 5 000 artisti, tra cui tutti i grandi del ventesimo secolo.

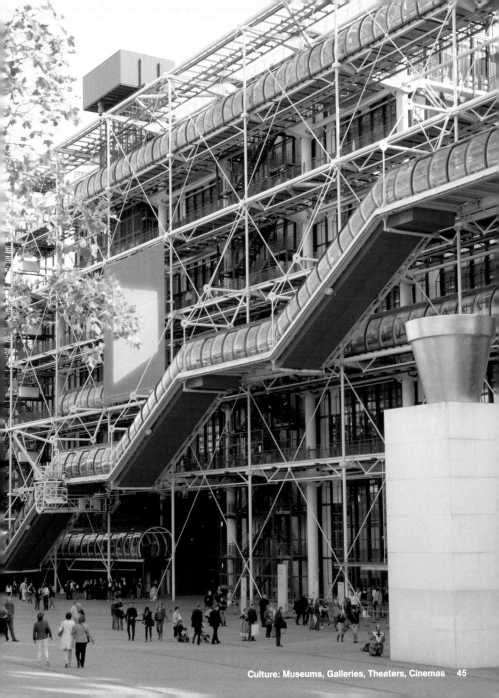

Musée Picasso

Hôtel Salé
5, rue de Thorigny
75003 Paris
3e Arrondissement
Phone: +33 / 142 71 25 21
www.musee-picasso.fr
www.parismuseumpass.fr

Opening hours: April–Sept Wed–Mon 9.30 am to 6 pm, Oct–March Wed–Mon 9.30 am to 5.30 pm; closed on 1st Jan and 25th Dec
Admission: € 9.50, 18 to 25 years € 7.50, free for children (18 and under) and with the Paris Museum Pass
Metro station: St-Paul, St-Sébastien - Froissart, Chemin Vert
Map: No. 44

The museum situated in the stately Hôtel Salé presents 75 years of creative work and documents all of the art phases that Pablo Picasso went through. It also allows insights into Picasso's private art collection, including works by Cézanne, Rousseau, and Miró and shows his fascination for African masks.

Le musée, situé dans le somptueux Hôtel Salé, présente 75 années de production créatrice et documente toutes les phases artistiques traversées par Pablo Picasso. En outre, il nous laisse entrevoir sa collection d'art privée avec des œuvres de Cézanne, Rousseau et Miró et nous montre sa fascination pour les masques africains.

El Museo ubicado en el soberbio Hôtel Salé presenta 75 años de producción creativa y documenta todas las fases de la carrera artística de Pablo Picasso. También, es posible visitar la colección privada del artista, con obras de Cézanne, Rousseau y Miró y apreciar la fascinación de Picasso por las máscaras africanas.

Il Museo è allestito nel sontuoso Hôtel Salé e presenta 75 anni di produzione creativa, documentando tutte le fasi artistiche attraversate da Pablo Picasso. È inoltre possibile ammirare la collezione privata dell'artista, con opere di Cézanne, Rousseau e Miró, oltre a maschere africane, di cui Picasso era appassionato.

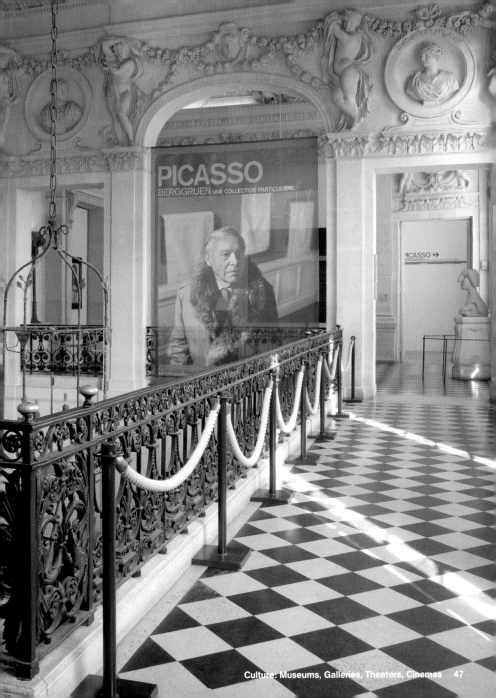

Musée National du Moyen Age – Hôtel de Cluny

6, place Paul-Painlevé
75005 Paris
5e Arrondissement
Phone: +33 / 153 73 78 16
www.musee-moyenage.fr
www.parismuseumpass.fr

Opening hours: Wed–Mon 9.15 am to 5.45 pm; closed on
1st Jan, 1st May and 25th Dec
Admission: € 7.50, concessions € 5.50, free for children (18 and
under) and on the first Sun of each month; audio guides in
6 languages included in the price
Metro station: Cluny - La Sorbonne
Map: No. 42

The palace of the Cluny abbots, which was built in the 15th century and houses the Musée National du Moyen Age, is located in the middle of Bohemia, boutiques, and bistros. The museum's main attractions are the six-part wall hanging with the motif of the *Lady with the Unicorn* from the 15th century and the sculptures of Notre-Dame.

Au milieu d'un quartier bohème, des boutiques et des bistros, se trouve l'Hôtel des Abbés de Cluny, construit au XVe siècle, qui héberge le Musée National du Moyen Age. Ses pièces maîtresses sont la tapisserie constituée de 6 tentures avec le motif de « La dame à la Licorne » du XVe siècle et les sculptures de Notre-Dame.

Entre bohemios, boutiques y bistrós, en un edificio del siglo XV se encuentra el l'Abbé de Cluny, que aloja el Museo Nacional de la Edad Media. Entre las muchas de las preciadas obras en exposición destacan el tapiz de 6 partes con el motivo "La Dama y el Unicornio", del siglo XV, y las esculturas de Notre-Dame.

Tra bohémien, boutique e bistrot, si trova il palazzo dell'Abbé de Cluny, costruito nel XV secolo, che ospita il Musée National du Moyen Age. Tra i molti pezzi pregiati in esposizione, segnaliamo soprattutto l'arazzo in sei parti con il motivo "La Dama dell'Unicorno" del XV secolo e le sculture di Notre-Dame.

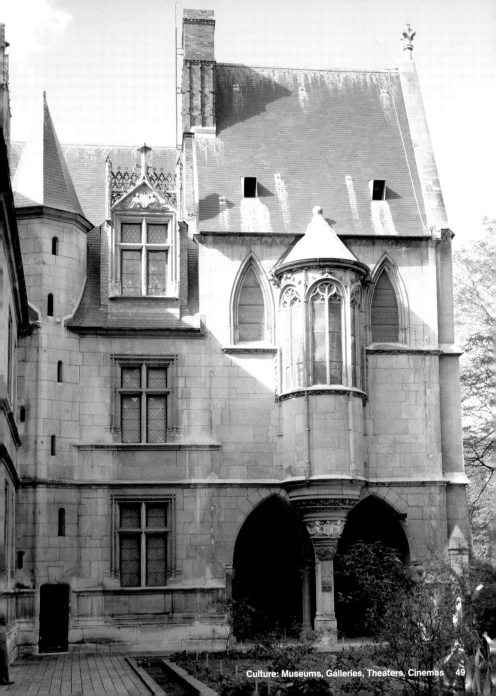

Musée d'Orsay

62, rue de Lille
75007 Paris
7e Arrondissement
Phone: +33 / 140 49 48 14
www.musee-orsay.fr
www.parismuseumpass.fr

Entrance to the museum: 1, rue de la Légion d'Honneur
Opening hours: Tue+Wed, Fri–Sun 9.30 am to 6 pm, Thu
9.30 am to 9.45 pm; closed on 1st Jan, 1st May and 25th Dec
Admission: € 7.50, concessions and Sun € 5.50; free with the
Paris Museum Pass
Metro station: Solférino, Musée d'Orsay
Map: No. 43

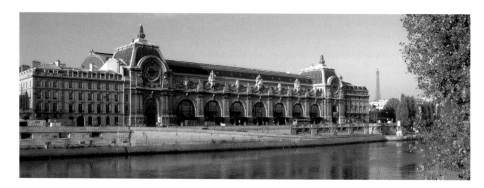

Built for the 1900 World Exposition, the Belle Epoque hall of the former Gare d'Orsay train station now comprehensively documents the creation of art between 1848 and 1914, including Edouard Manet's *Déjeuner sur l'herbe* (Luncheon on the Grass) and Paul Gauguin's *Femmes de Tahiti* (Tahitian women). The museum, which opened in 1986, is therefore a connecting link between the Louvre and the Centre Pompidou.

Dans les salles Belle époque de l'ancienne Gare d'Orsay, construites pour l'exposition universelle de 1900, la production artistique de la période entre 1848 et 1914 est amplement documentée, comprenant entre autres le « Déjeuner sur l'herbe » d'Edouard Manet et les « Femmes de Tahiti » de Paul Gauguin. Le Musée, ouvert en 1986, fait donc le lien entre le Louvre et le Centre Pompidou.

El pabellón Belle-Époque de la antigua estación Gare d'Orsay, erigido en el año 1900 con motivo de la Exposición Mundial, documenta hoy al completo la producción artística de la época comprendida entre los años 1848 y 1914; destacan obras como "Desayuno en la Hierba" de Édouard Manet, y "Dos Mujeres en la Playa" de Paul Gauguin. El Museo, inaugurado en el año 1986, hace de nexo de unión entre el Louvre y el Pompidou.

Allestita nel 1900 in occasione dell'Esposizione Mondiale, la sala Belle Époque dell'ex stazione Gare d'Orsay testimonia oggi ampiamente la produzione artistica dell'epoca tra il 1848 e il 1914; da segnalare la "Colazione sull'erba" di Edouard Manet e le "Donne di Tahiti" di Paul Gauguin. Il museo, aperto nel 1986, è una sorta di collegamento tra il Louvre e il Centro Pompidou.

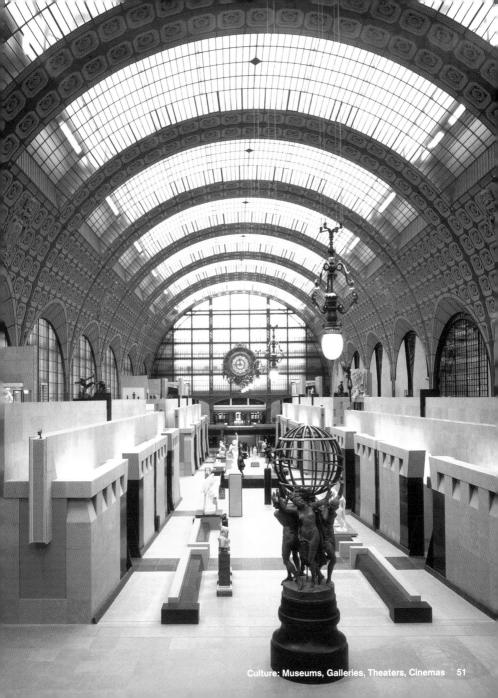

Musée Quai Branly

37, quai Branly – Portail Debilly
75007 Paris
7e Arrondissement
Phone: +33 / 156 61 70 00
www.quaibranly.fr

Opening hours: Tue–Sun 10 am to 6.30 pm, Thu to 9.30 pm
Admission: € 10, under 18 years € 7.50, free for children and every first Sun of each months; audio guide € 15, concessions € 12.50
Ticket service: Advance booking available through the internet or calling 0 892 684 694
Metro station: Iéna, Alma - Marceau, Pont de l'Alma
Map: No. 45

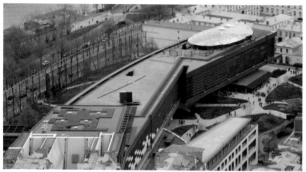 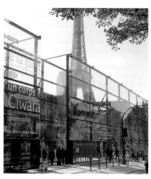

Since opening its doors in June 2006, the museum has been dedicated to foreign peoples and tribes of Africa, Asia, Oceania, and America. It pays an extensive tribute to the civilizations and cultures that have often been disdained by the Western world. About 300,000 objects previously housed in other museums are preserved here in the building designed by Jean Nouvel.

Ce musée, ouvert en juin 2006, est dédié aux tribus et peuples étrangers d'Afrique, d'Asie, d'Océanie et d'Amérique. Ici, on rend hommage en détails à des civilisations et cultures souvent négligées par le monde occidental. Dans le bâtiment conçu par Jean Nouvel, on conserve environ 300 000 objets qui se trouvaient auparavant dans d'autres musées.

El museo inaugurado en junio de 2006 está dedicado a etnias y poblaciones africanas, asiáticas, de Oceanía y de América. Aquí se ponen de relieve civilizaciones y culturas que a menudo han sido olvidadas por el mundo occidental. El edificio, concebido por Jean Nouvel, reúne y expone 300 000 piezas que anteriormente se encontraban en distintos museos.

Aperto nel giugno 2006, il museo è dedicato alle etnie e alle popolazioni africane, asiatiche, dell'Oceania e delle Americhe. È un omaggio alle civiltà e alle culture spesso trascurate dal mondo occidentale. L'edificio, concepito da Jean Nouvel, raccoglie circa 300 000 pezzi provenienti da altri musei.

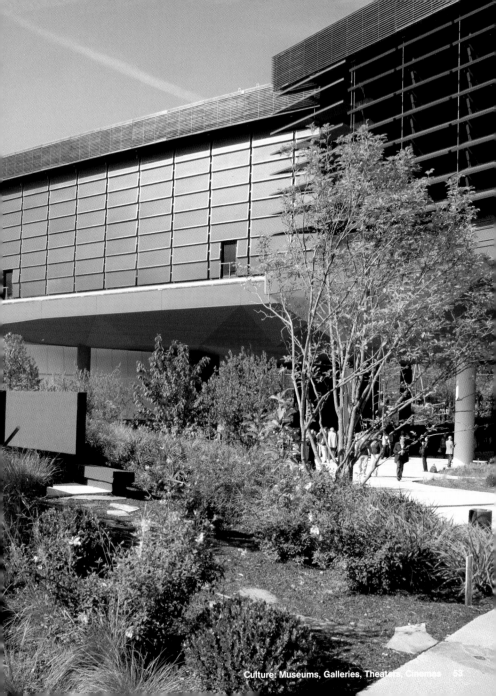

Musée National des Arts Asiatiques – Guimet

6, place d'Iéna
75116 Paris
16e Arrondissement
Phone: +33 / 156 52 53 00
www.museeguimet.fr
www.parismuseumpass.fr

Opening hours: Wed–Mon 10 am to 6 pm;
garden restaurant Maxence Phone: +33 / 147 23 58 03
Admission: € 6, concessions € 4; free with Paris Museum Pass
Metro station: Iéna, Trocadéro, Boissière
Map: No. 41

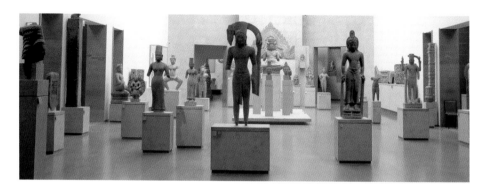

The museum founded by Emile Guimet holds the largest collection of Asian art outside of Asia. 50,000 art treasures from 17 countries are displayed, the absolute highlight of which is a 14-headed sculpture from Angkor Wat. Religious works from China and Japan can be viewed in an annex.

Ce musée, fondé par Emile Guimet, comprend la plus grande collection d'art asiatique en dehors de l'Asie. 50 000 trésors provenant de 17 pays sont exposés ici, dont le chef d'œuvre absolu est une sculpture à 14 têtes en provenance d'Angkor Wat. Un bâtiment annexe présente des œuvres religieuses de la Chine et du Japon.

El museo fundado por Emile Guimet incluye la colección más grande de arte asiático fuera de Asia. Aquí se muestran 50 000 tesoros de arte de 17 países, culminando en la escultura con 14 cabezas procedente de Angkor Wat. En uno de sus edificios anexos es posible admirar obras religiosas procedentes de China y Japón.

Fondato da Emile Guimet, custodisce la più grossa collezione di arte asiatica fuori dall'Asia. Sono esposti 50 000 tesori d'arte provenienti da 17 nazioni, il più pregiato dei quali è una scultura a 14 teste proveniente da Angkor Wat. In una dépendance si possono ammirare opere religiose provenienti dalla Cina e dal Giappone.

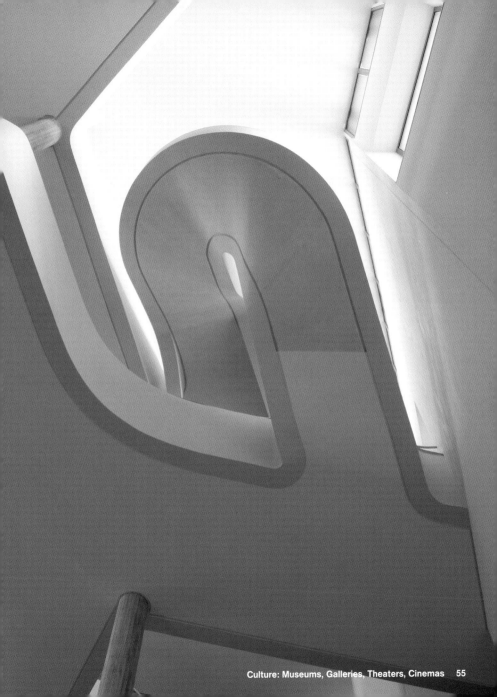

Musée d'Art Moderne de la Ville de Paris

11, avenue du Président-
Wilson
75016 Paris
16e Arrondissement
www.mam.paris.fr

Opening hours: Tue–Sun 10 am to 6 pm, Wed to 10 pm
Admission: € 7, temporary exhibition free
Metro station: Alma - Marceau, Iéna
Map: No. 39

This internationally recognized museum is set up in an extraordinary building from 1937. More than 10,000 works reflect the creativity of French and other European artists from the 20th century. The ARC division is dedicated to the most recent currents of contemporary art from France and around the world.

Ce musée de renom international est hébergé dans un bâtiment exceptionnel datant de 1937. Plus de 10 000 œuvres reflètent la création d'artistes français et européens du XXe siècle. Le département de l'ARC est consacré aux courants d'art contemporains récents de la France et du monde.

Este museo de fama internacional está ubicado en el interior de un curioso edificio, construido en 1937. Las 10 000 obras expuestas atestiguan la trayectoria de artistas franceses y europeos del siglo XX. La sección ARC está dedicada a las más recientes tendencias artísticas contemporáneas en Francia y en el resto del mundo.

Ben noto a livello internazionale, il museo è ospitato in un singolare edificio, costruito nel 1937. Oltre 10 000 opere rispecchiano la produzione artistica francese ed europea del ventesimo secolo. La sezione ARC è dedicata alle più recenti tendenze artistiche contemporanee francesi ed internazionali.

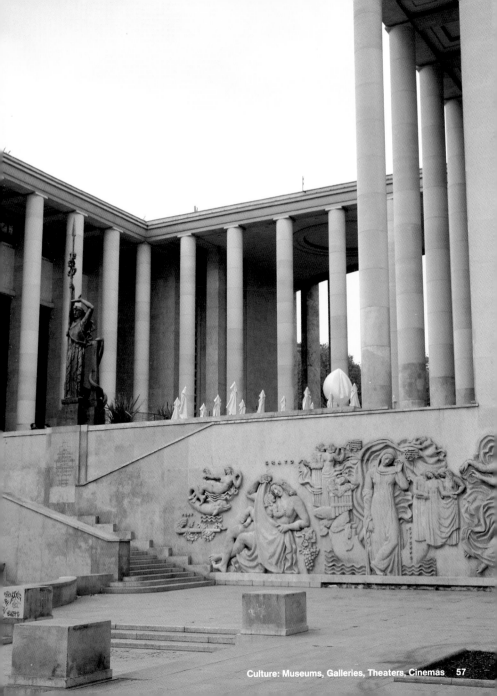

Musée Rodin

Hôtel Biron
79, rue de Varenne
75007 Paris
7e Arrondissement
Phone: +33 / 144 18 61 10
www.musee-rodin.fr
www.parismuseumpass.fr

Opening hours: April–Sept Tue–Sun 9.30 am to 5.45 pm,
Oct–March Tue–Sun 9.30 am to 4.45 pm
Admission: € 6 for permanent exhibitions and the garden,
garden on its own € 1, 18 to 25 years € 4, free for up to 18 years
and with Paris Museum Pass
Metro station: Varenne
Map: No. 46

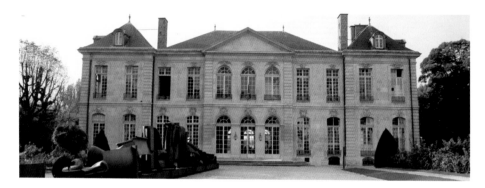

The museum is located in the splendid Hôtel Biron, where the sculptor Auguste Rodin lived and worked from 1908 until his death in 1917. The works of his student and lover of many years, Camille Claudel, are also displayed in addition to Rodin's works. The large garden also contributes to the charm of the estate, in which famous works like *The Gates of Hell* and *The Burghers of Calais* can be admired.

Le musée se trouve dans le superbe Hôtel Biron, où le sculpteur Auguste Rodin vécut et travailla de 1908 à sa mort en 1917. A côté de ses œuvres, sont également exposées celles de Camille Claudel, sa disciple et sa maîtresse pendant de longues années. Le grand parc, dans lequel on peut admirer des œuvres connues comme la « Porte de l'Enfer » et « Les Bourgeois de Calais », contribue au charme de ce domaine.

El Museo se encuentra en el magnífico Hôtel Biron, donde el escultor Auguste Rodin vivió y trabajó desde 1908 hasta su muerte en 1917. En él se exponen sus trabajos y los de Camille Claudel, su discípula y amante durante años. El amplio jardín añade aún más encanto a la propiedad: allí se pueden admirar las más famosas obras del gran artista: la "Puerta del Infierno" y los "Burgueses de Calais".

Il museo si trova nel magnifico Hôtel Biron, dove lo scultore Auguste Rodin visse e lavorò dal 1908 fino alla morte, avvenuta nel 1917. Oltre alle opere del grande artista, sono esposti anche lavori di Camille Claudel, che fu per lungo tempo sua allieva e amante. Il vasto giardino, nel quale è possibile ammirare famose opere quali la Porta dell'Inferno e i Borghesi di Calais, conferisce fascino alla tenuta.

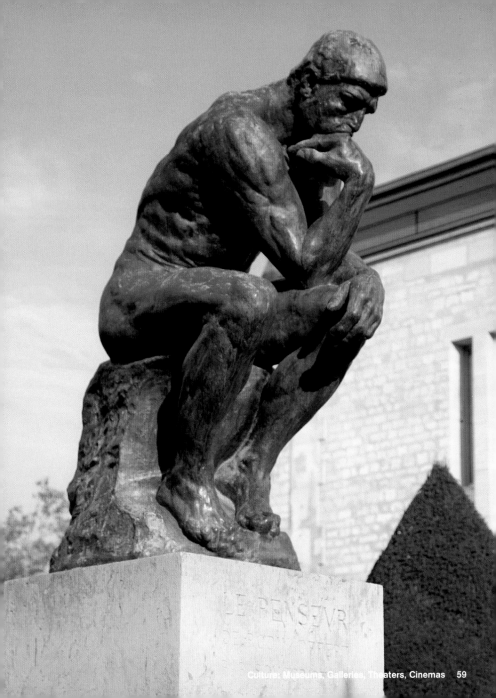

LE PENSEVR

Fondation Le Corbusier

8–10, square du Docteur-
Blanche
75016 Paris
16e Arrondissement
Phone: +33 / 142 88 75 72
www.fondationlecorbusier.fr

Opening hours: Mon 1.30 pm to 6 pm, Tue–Thu 10 am to
12.30 pm and 1.30 pm to 6 pm, Fri to 5 pm, Sat 10 am to 5 pm;
closed on Sun, Mon mornings, on legal holidays and 7th Aug–
15th Aug
Admission: Free
Metro station: Jasmin, Michel-Ange - Auteuil
Map: No. 20

Long before his death, the Swiss architect Le
Corbusier established the foundation and
made it the sole heir of his complete works.
These works include drawings, paintings,
sculptures—and obviously the world-famous
Le Corbusier armchair—displayed in the villas
Jeanneret and *La Roche* built by the architect.

Longtemps avant sa mort, l'architecte suisse
Le Corbusier a créé cette fondation qu'il a
désignée comme seule héritière de son œuvre
complète. Dans les villas « Jeanneret » et
« La Roche » qu'il a lui-même construites, on
trouve, entre autres, des dessins, des peintures,
des sculptures – et bien sûr, les fauteuils Le
Corbusier mondialement connus.

Mucho antes de morir, el arquitecto suizo
Le Corbusier instituyó su propia fundación
nombrándola heredera universal de todas
sus obras. Hizo construir las villas *Jeanneret*
y *La Roche*, donde se encuentran, entre otras
piezas, dibujos, pinturas, esculturas, y por
supuesto las célebres sillas Le Corbusier.

L'architetto svizzero Le Corbusier istituì la
propria fondazione molto prima della morte,
designandola erede universale delle sue opere.
Nelle ville *Jeanneret* e *La Roche*, da lui costruite,
si trovano, tra l'altro, disegni, dipinti, sculture –
e naturalmente le famosissime poltrone Le
Corbusier.

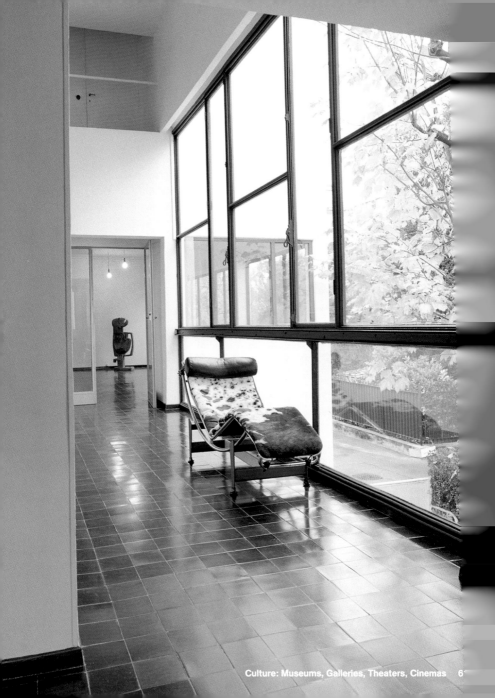

Opéra de la Bastille

120, rue de Lyon
75012 Paris
12e Arrondissement
Phone: 08 92 89 90 90 (only inside France)
+33 / 172 29 35 35
www.operadeparis.fr

Season: A performances calendar is available on their website.
Ticket service: Advance booking by phone on +33 / 172 29 35 35
Box office: 130, rue de Lyon, for the first performances in the season from July daily 10.30 am to 6.30 pm, except Sun and on legal holidays
Metro station: Bastille
Map: No. 49

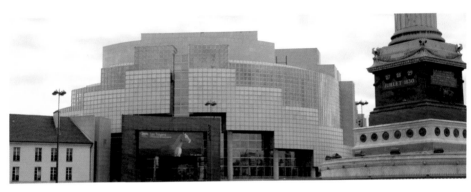

Despite the unsatisfactory acoustics, the opera that was inaugurated in 1989 is a structure of superlatives. It has a total area of 525,000 sq ft, nine different stages, and each of the 2,700 seats offers an unrestricted view of the stage. Even for modest budgets, this is a guaranteed feast for the eyes.

Malgré une acoustique peu satisfaisante, cet opéra, inauguré en 1989, est le bâtiment des superlatifs. Sur une superficie totale de 160 000 m², il y a de la place pour neuf scènes différentes, et chacun des 2 700 sièges assure une vue dégagée sur la scène : un régal pour les yeux, même pour un budget modeste.

A pesar de su acústica insuficiente, el edificio no deja de ser un superlativo. Fue construido en el año 1989 y cuenta con una superficie de 160 000 m², con nueve palcos escénicos, y cada uno de los 2 700 asientos ofrece una vista sin obstáculos al escenario: un espectáculo estupendo, también a precios asequibles.

Nonostante l'acustica insoddisfacente, l'edificio è superlativo. Inaugurata nel 1989, l'Opéra ha un'area complessiva di 160 000 metri quadrati, alloggia nove diversi palcoscenici e da ognuno dei 2 700 posti a sedere si ha una visuale illimitata delle scene: uno spettacolo stupendo, accessibile anche a budget moderati.

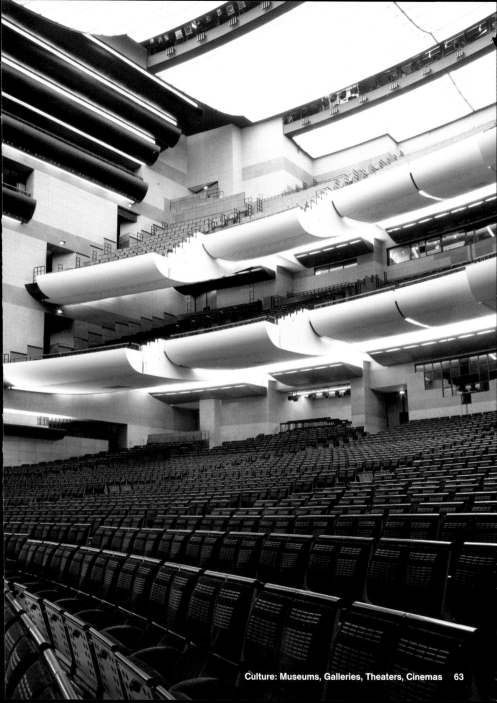

Cité de la Musique

221, avenue Jean-Jaurès
75019 Paris
19e Arrondissement
Phone: +33 / 144 84 44 84
www.cite-musique.fr
www.parismuseumpass.fr

Opening hours: Tue–Sat noon to 6 pm, Sun 10 am to 6 pm;
library on days of performance to 8 pm; Media Center Tue–Sat
noon to 6 pm, Sun 1 pm to 6 pm
Admission: € 7, free for children (18 and under) and with a Paris
Museum Pass; Media Center free, concerts € 8 to € 38
Metro station: Porte de Pantin
Map: No. 13

 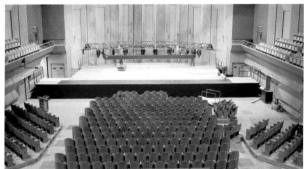

The futuristic complex of the Cité de la Musique in La Villette invites visitors into the world of music with a concert hall, media center, and museum. Various musical styles from the Renaissance to classical music up to jazz and pop are presented while also remaining open to the music of other cultures.

A La Villette, le complexe futuriste de la Cité de la Musique avec salle de concert, médiathèque et musée vous invite dans le monde de la musique. Différents styles de musique, de la Renaissance et de la musique classique au jazz et à la pop musique, sont présentés, sans oublier la musique d'autres cultures.

Este complejo futurista en La Villette invita a entrar al paraíso de la música con su sala de conciertos, mediateca y museo. Los géneros que se presentan son diversos, desde el renacentista o el clásico hasta el jazz o el pop. La puerta está abierta también a las expresiones musicales de otras culturas.

Il complesso futuristico Cité de la Musique ne La Villette, con la sua sala da concerti, la mediateca e il museo, ci invita nel mondo della musica. I generi proposti sono diversi, dal rinascimentale al classico fino al jazz e al pop, e la porta è aperta anche alle espressioni musicali di altre culture.

Cité des Sciences et de l'Industrie

30, avenue Corentin-Cariou
75019 Paris
19e Arrondissement
Phone: +33 / 140 05 80 00
www.cite-sciences.fr
www.parismuseumpass.fr

Opening hours: Tue–Sat 10 am to 6 pm, Sun to 7 pm
Admission: € 8, concession € 6, free for children (7 and under) and with a Paris Museum Pass; Cité des enfants € 6; La Géode € 9, 25 and under € 7
Metro station: Porte de la Villette
Map: No. 14

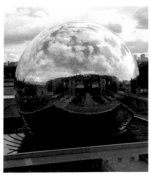 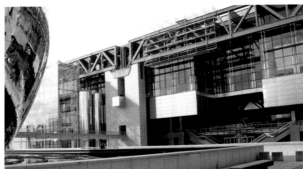

The city of sciences and industry: In the thematically arranged departments of the museum, scientific phenomena become easy to understand with the help of numerous interactive games. The sphere of La Géode on the opposite side of the street invites visitors to a special 3-D movie experience.

La Cité des Sciences et de l'Industrie : dans les sections thématiques du musée, des phénomènes scientifiques sont expliqués de manière compréhensible à l'aide de nombreux jeux interactifs. La sphère de La Géode, située en face, vous propose l'expérience exceptionnelle de la 3D-relief.

En las distintas secciones del Museo, distribuidas por temas, se explican fenómenos científicos y naturales de forma comprensible a través de juegos interactivos. La esfera La Géode, situada desde una vista frontal, invita a una especial experiencia cinematográfica en tres dimensiones.

La città delle scienze e dell'industria: nelle varie sezioni del museo, organizzate per tema, si descrivono in modo facilmente comprensibile, grazie a numerosi giochi interattivi, vari fenomeni scientifici e naturali. La sfera La Géode, situata di fronte, invita a una speciale esperienza cinematografica a tre dimensioni.

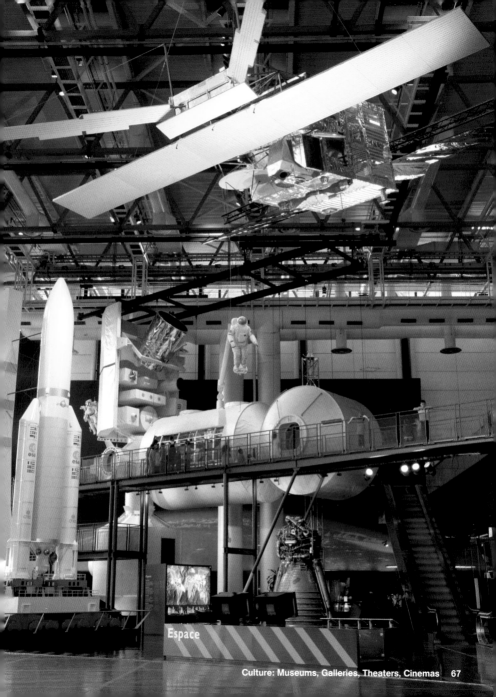

Espace

Restaurants Cafés Bars Clubs

Eating is still an integral part of the French culture, and Paris is a first-rate me
realm. All of the world's taste experiences are united here, whether in the luxuria
cultures or in an ambience created by one of the current design gurus. Not just the
are important but also the appropriate setting. Besides, the traditional bistros also co
tract a following of their own.

Les repas sont encore partie intégrante de la culture française, et Paris est aussi une métro
gastronomique de premier rang. Ici, toutes les saveurs du monde sont réunies, que ce soit dan
décor luxuriant de cultures étrangères ou dans l'ambiance créée par les célébrités actuelles du de
sign. Car les repas exquis ont autant d'importance que le cadre correspondant. Mais les bons vieux
bistros savent aussi se défendre.

La cocina sigue siendo una parte fundamental de la cultura francesa y París es una metrópoli de
primera categoría en el sector culinario. Aquí se experimenta con sabores del mundo entero en
locales lujosamente decorados de estilo étnico o diseñados por los grandes del interiorismo, ya que
no sólo cuentan los exquisitos platos, sino también el ambiente adecuado. Y los antiguos bistrós
mantienen su lugar.

Il cibo è ancor sempre una parte integrante della cultura francese, e Parigi è una metropoli all'avan-
guardia anche nel settore culinario. Qui si incontrano tutti i sapori del mondo, in locali riccamente
arredati in stile etnico o in ambienti progettati dai grandi nomi del design. Ciò che conta, infatti, non
sono solo le squisite pietanze, ma anche la cornice che le propone. Anche il buon vecchio bistrot,
tuttavia, non perde mai il suo fascino.

Left page: Market, **right page:** Left Brasserie Lipp, right Le Train Bleu

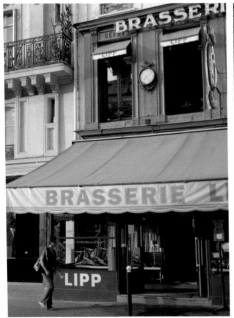
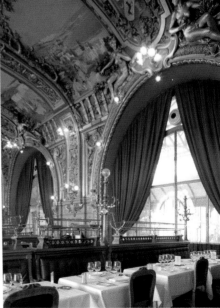

tropolis in the culinary
nt decor of foreign
exquisite foods
ntinue to at-

opole
le

Opening hours: Daily 9 am, last order at 12.45 am
Prices: From € 45 à la carte
Cuisine: Traditional French
Metro station: Saint-Germain-des-Prés
Map: No. 4
Editor's tip: A reservation is essential. The best tables are found on the first floor.

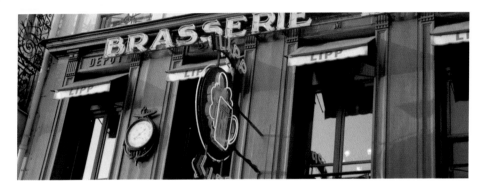

The world-famous brasserie has offered solid Alsatian cuisine—in respectable portions—since 1880. For years, the restaurant has been a meeting place for stars of politics, culture, and society. Even just the Belle Epoque architecture with its ceramic tiles and wood paneling is worth the visit.

Depuis 1880 déjà, cette brasserie de renommée mondiale sert une cuisine alsacienne roborative – avec de généreuses portions. Cet établissement est depuis toujours le rendez-vous des vedettes de la politique, de la culture et de la société. L'architecture Belle Epoque, avec ses carreaux de faïence et ses lambris de bois, vaut à elle seule le déplacement.

Esta cervecería famosa en el mundo entero ofrece desde 1880 sabrosa cocina alsaciana en raciones respetables. El local es desde siempre centro de encuentro de personalidades políticas, culturales y del mundo financiero. Ya sólo por admirar la arquitectura Belle-Époque con sus azulejos y paneles de madera merece la pena entrar.

Già dal 1880 questa brasserie, celebre in tutto il mondo, propone la sostanziosa cucina alsaziana – in porzioni di tutto rispetto. Da sempre punto d'incontro di personalità del mondo della politica, della cultura e della società, merita sempre una visita, anche solo per l'architettura Belle Époque con piastrelle in ceramica e pannellature in legno.

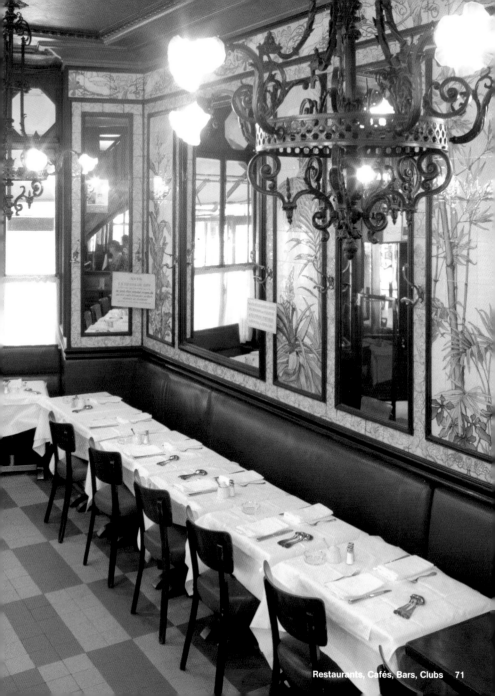

Le Buddha Bar

8, rue Boissy d'Anglas
75008 Paris
8e Arrondissement
Phone: +33 / 153 05 90 00
www.buddhabar.com

Opening hours: Daily 4 pm; reservation is recommended
Prices: Lunch € 32 to € 35, dinner € 70 to € 80
Cuisine: International
Metro station: Concorde
Map: No. 5

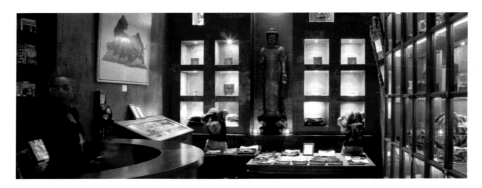

Buddha Bars can also be found in New York, Beirut, and Dubai: Opulent and kitschy furnishings are part of the design concept. Immersed in soft light, you can dine at the feet of a gigantic Buddha statue and listen to Zen sounds. Unusual exotic dishes are offered in addition to many traditional Asian specialties.

Il existe aussi des Buddha Bars à New York, Beyrouth et Dubai : l'intérieur opulent et kitsch fait partie du concept de design. On dîne, baigné d'une lumière douce, aux pieds d'une gigantesque statue de Bouddha, aux sons d'une musique zen. Outre de nombreuses spécialités asiatiques traditionnelles, il y a aussi des surprises exotiques.

La cadena Buddha Bar está presente también en Nueva York, Beirut y Dubai: la opulenta decoración kitsch es parte del concepto de diseño. El visitante está inmerso en una luz suave, en el sonido de música Zen y custodiado por un gigantesco Buda. La carta incluye numerosas especialidades asiáticas tradicionales e insólitos platos exóticos.

Il Buddha Bar è anche a New York, Beirut e Dubai: l'arredamento, opulento e kitsch, è ormai un punto fermo del design. Si pranza immersi in una luce tenue, ai piedi della gigantesca figura di un Buddha e al suono di musica Zen. L'offerta comprende molte specialità asiatiche tradizionali e altre pietanze esotiche più insolite.

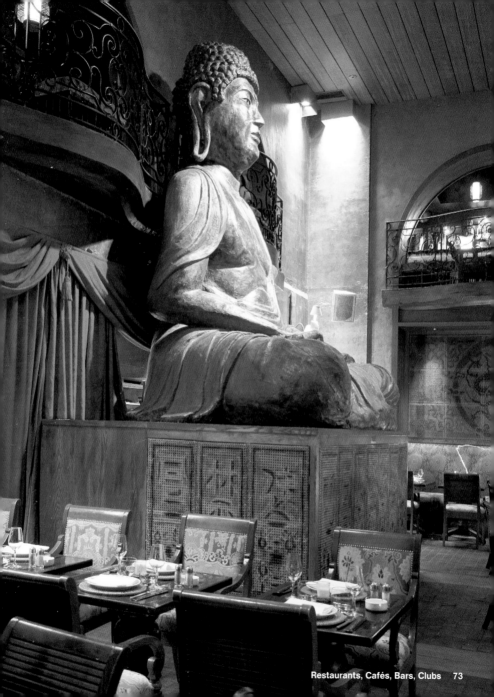

Café de l'Homme

17, place du Trocadéro
75016 Paris
16e Arrondissement
Phone: +33 / 144 05 30 15
www.lecafedelhomme.com

Opening hours: Daily noon to 2 am
Prices: A la carte € 24 to € 55, menu € 25 and € 30
Cuisine: Modern and traditional
Metro station: Trocadéro
Map: No. 6

The restaurant of the museum by the same name in the Palais de Chaillot presents a wonderful view from its terrace, including the Eiffel Tower. The interior is impressive with its high ceilings and colonnades in the Bauhaus and Art Deco style. French cuisine is fused with recipes from distant regions here.

Le restaurant du musée du même nom dans le Palais de Chaillot offre une superbe vue depuis sa terrasse, entre autres sur la Tour Eiffel. L'intérieur impressionne avec des salles hautes et des colonnades dans les styles Bauhaus et Art déco. La cuisine française est combinée ici avec des recettes de lointaines régions.

El restaurante, situado en el homónimo museo del Palais de Chaillot, ofrece una vista magnífica desde su terraza, Torre Eiffel incluida. La decoración impacta por su altos espacios y sus columnas de estilo Bauhaus y Art déco. En su carta la gastronomía francesa se funde con especialidades de regiones lejanas.

Il ristorante del museo omonimo nel Palais de Chaillot offre dalla terrazza una magnifica vista che abbraccia anche la Torre Eiffel. L'interno colpisce per i suoi alti spazi e per i colonnati in stile Bauhaus e Art déco. La cucina francese si sposa con specialità delle regioni più remote.

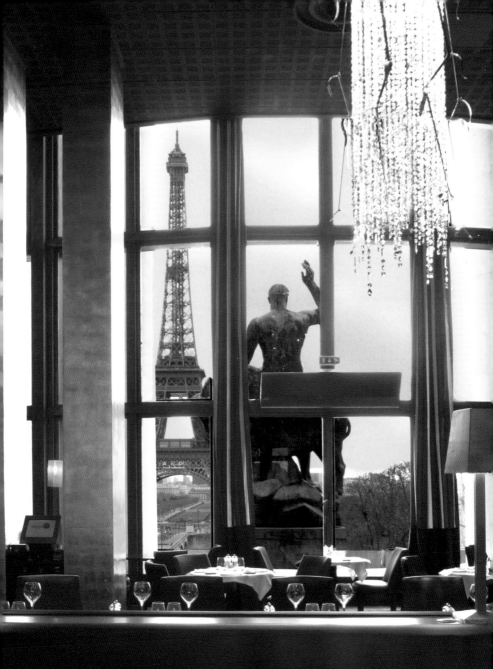

Chartier

7, rue du Faubourg-Montmartre
75009 Paris
9e Arrondissement
Phone: +33 / 147 70 86 29
www.restaurant-chartier.com

Opening hours: Daily 11.30 am to 3 pm and 6 pm to 10 pm;
reservations at bouillon.chartier@wanadoo.fr
Prices: From € 8.50
Cuisine: Traditional French
Metro station: Grands Boulevards
Map: No. 9

The traditional canteen-style establishment, which is listed on a historic register, offers tourists simple food at moderate prices on long tables. This is not for people who like to keep to themselves. Opened in 1896 as a workers' bar, gruff waiters and carelessly prepared meals are on the agenda here.

Cet établissement traditionnel, classé monument historique, sert aux touristes, sur de longues tables dans un style cantine, des repas simples à prix modérés. Une ambiance qui ne convient guère à ceux qui veulent rester entre eux. Comme c'était un bistro ouvrier à l'ouverture en 1896, les serveurs sont peu affables et les plats mal présentés.

Este local, nombrado monumento, cargado de tradición y decorado al estilo de una bodega ofrece cocina sencilla a precios módicos, lo cual significa que no es adecuado para quienes busquen intimidad. El establecimiento abrió en 1896 como taberna para obreros, de ahí que también entren en el programa camareros descorteses y platos preparados de mala gana.

Tutelato come monumento, questo locale tradizionale in stile cantina, arredato con lunghi tavoli, offre ai turisti cibo semplice a prezzi modici. Non è indicato per chi cerca un ambiente intimo. Fu aperto nel 1896 come osteria per gli operai: i camerieri dai modi rozzi e il cibo spartanamente servito fanno parte del programma.

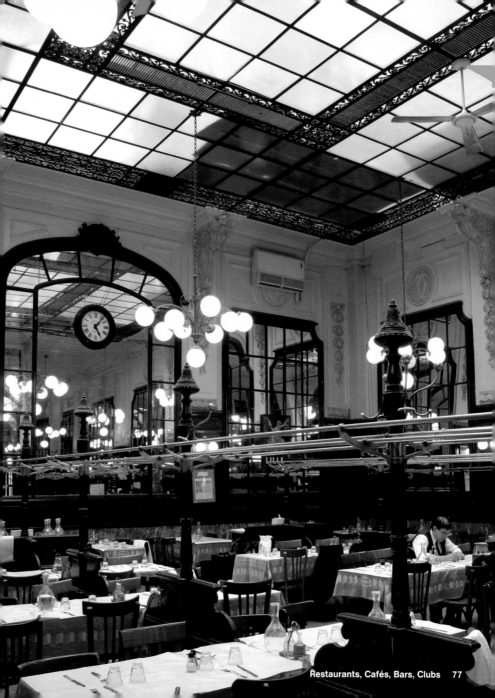

Chez Georges

Centre Georges Pompidou
19, rue Beaubourg
6th Floor
75004 Paris
4e Arrondissement
Phone: +33 / 144 78 47 99
www.centrepompidou.fr

Opening hours: Daily except Tue
Prices: € 40 to € 100 à la carte
Cuisine: Modern
Metro station: Rambuteau, Châtelet - Les Halles
Map: No. 10

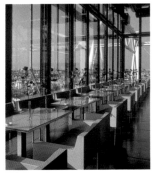
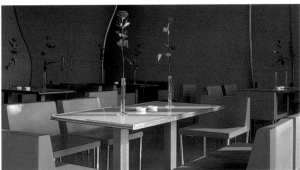

The futuristic-looking restaurant on the seventh floor of the Centre Pompidou, which owes its name to the former president Georges Pompidou, serves traditional dishes like cassoulet or sweetbread. The service is flawless and friendly. You can enjoy an unforgettable view of the metropolis from the terrace.

Ce restaurant futuriste au sixième étage du Centre Pompidou qui doit son nom à l'ancien président de la République Georges Pompidou, sert des repas traditionnels comme le cassoulet ou le ris de veau. Le service est aimable et impeccable. De la terrasse, la vue sur la métropole est inoubliable.

Este restaurante de sabor futurista en la sexta planta del Centro Pompidou, que debe su nombre al antiguo Presidente de la República Georges Pompidou, sirve platos tradicionales como cassoulet y mollejas de ternera. El servicio es impecable y agradable. La terraza brinda una vista inolvidable de la metrópoli.

Questo ristorante dal gusto futurista situato al sesto piano del Centro Pompidou, che deve il nome all'ex Presidente della Repubblica Georges Pompidou, è specializzato in piatti tradizionali come cassoulet e animelle di vitello. Il servizio è impeccabile e cortese. Dalla terrazza si gode una vista indimenticabile sulla metropoli.

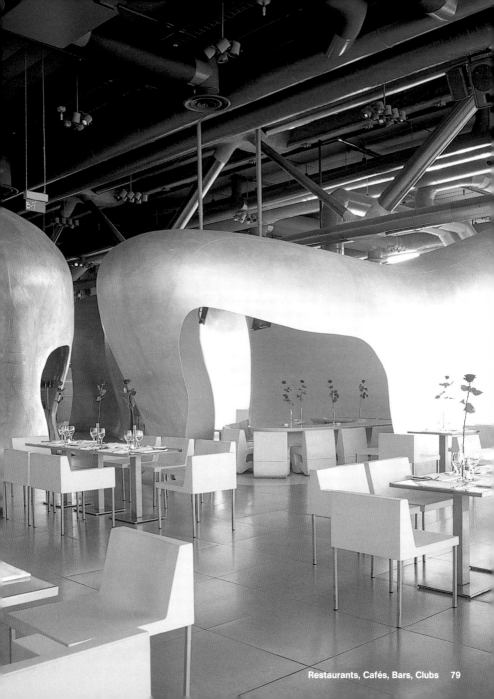

Market

15, avenue Matignon
75008 Paris
8e Arrondissement
Phone: +33 / 156 43 40 90
www.jean-georges.com

Opening hours: Daily Mon–Fri 8 am to 3 pm and 7 pm to 11.30 pm, from 6 pm cocktails, Sat+Sun noon to 6 pm brunch; reservation is recommended
Prices: Menu à la carte with a drink € 34, € 55 to € 65 and € 75 to € 95
Cuisine: Seasonal French, Italian and Asian
Metro station: Franklin D. Roosevelt
Map: No. 35

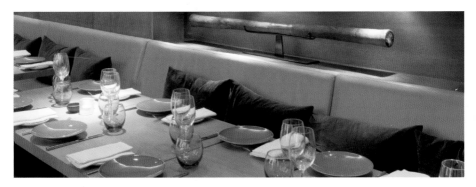

In his eleventh restaurant, Alsatian Jean-Georges Vongerichten combines seasonal French recipes with Asian, Italian, and Californian elements into world-class fusion cuisine. In addition to meal combinations that are often full of surprises, the drinks are also exquisite and varied.

Dans son onzième restaurant, l'alsacien Jean-Georges Vongerichten réunit des recettes françaises de saison avec des éléments asiatiques, italiens et californiens dans une cuisine fusionnée au plus haut niveau. Outre des plats aux compositions surprenantes, il y a aussi des boissons délicieuses et variées.

En su undécimo restaurante, el alsaciano Jean-Georges Vongerichten concilia recetas francesas y elementos asiáticos, italianos y californianos, obteniendo una cocina de "fusión" al máximo nivel. Además de los platos, a menudo con sorprendentes combinaciones, las bebidas son igualmente exquisitas y variadas.

Nel suo undicesimo ristorante, l'alsaziano Jean-Georges Vongerichten unisce ricette francesi di stagione ad elementi asiatici, italiani e californiani, ottenendo una cucina di "fusione" di altissimo livello. Oltre ai cibi, spesso combinati in modo insolito, anche le bevande sono squisite e varie.

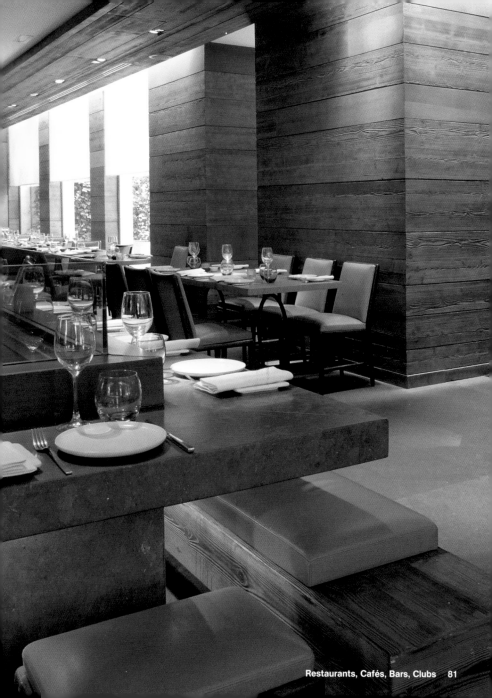

Le Train Bleu

Place Louis-Armand
75012 Paris
12e Arrondissement
Phone: +33 / 143 43 09 06
www.le-train-bleu.com

Opening hours: Bar daily 7.30 am to 11 pm, weekends and legal holidays 9 am to 11 pm, Restaurant daily 11.30 am to 3 pm and 7 pm to 11 pm; reservation is recommended
Prices: Menu from € 46, junior menu € 15
Cuisine: Traditional French
Metro station: Gare de Lyon
Map: No. 58

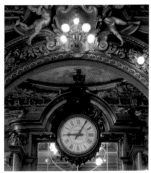

The Belle Epoque restaurant in the Gare de Lyon is impressively reminiscent of the late 19th century: Stucco and gilded moldings, crimson drapes, dark wood paneling, murals, and frescos on the ceilings are part of the ornate furnishings. The kitchen with its home-style cooking serves classic French dishes.

Ce restaurant Belle Epoque dans la Gare de Lyon rappelle la fin du XIXe siècle de manière impressionnante : stuc, moulures dorées, tentures pourpres, boiseries sombres et peintures aux murs et au plafond forment un cadre somptueux. La carte propose une cuisine traditionnelle française d'une modernité classique.

El restaurante Belle Époque en la Gare de Lyon es un impresionante recuerdo del final del siglo XIX: los estucos y los adornos en oro, las cortinas rojo púrpura, los paneles oscuros y la policromía de las paredes y del techo forman parte de la espléndida decoración. La cocina es del más puro estilo clásico francés.

Questo ristorante Belle Époque nella Gare de Lyon ricorda in modo impressionante il tardo secolo XIX: lo stucco e gli ornamenti in oro, i tendaggi rosso porpora, le pannellature scure e i dipinti dei muri e del soffitto costituiscono una splendida ambientazione. La cucina borghese serve piatti francesi classici.

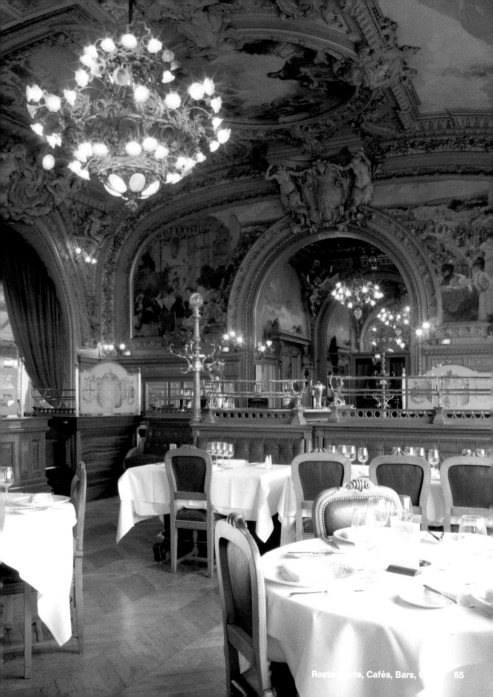

Nirvana Inde

6, rue de Moscou
75008 Paris
8e Arrondissement
Phone: +33 / 101 45 22 27 12
www.bestrestaurantparis.com

Opening hours: Mon–Sat noon to 2.30 pm and 6 pm to
11.30 pm, closed on Sun; reservation is recommended
Prices: Menu € 25
Cuisine: Indian
Metro station: Liège
Map: No. 47

This restaurant, which is popular among actors from the surrounding theaters, offers the genuine, traditional cuisine of India and Pakistan in an elegant atmosphere. Subtle herb and spice mixtures create a well-balanced, harmonious taste. The wine list perfectly complements these aromas.

Ce restaurant, très prisé des acteurs des théâtres alentour, offre une véritable cuisine traditionnelle de l'Inde et du Pakistan dans une atmosphère élégante. De subtils mélanges d'herbes et d'épices créent des harmonies culinaires équilibrées. La carte des vins complète parfaitement les arômes.

El restaurante favorito de los actores del teatro adyacente propone cocina tradicional genuina india y pakistaní en una atmósfera elegante. Delicadas mixturas de yerbas y especias crean equilibradas armonías de sabor y la carta de vinos complementa los aromas a la perfección.

Molto apprezzato dagli attori dei vicini teatri, il ristorante offre una genuina cucina tradizionale indiana e pakistana in un'atmosfera elegante. Delicati misti di erbe e aromi creano equilibrate armonie di sapore, perfettamente integrate dai vini che le accompagnano.

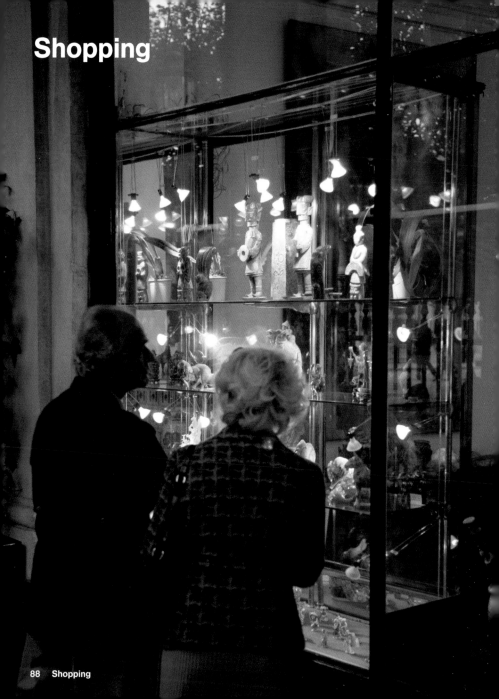

Shopping

The fashion trends, accessories, elegant furnishings, cosmetics, and fragr
Paris than almost anywhere in the world. Even the department stores offer g
gant fashion can be found in the boutiques in the Marais district, so there is so
every budget. But if you love art, you may find just what you were searching for a
Belleville.

L'offre en matière de mode, accessoires, aménagement élégant, produits cosmétiques et p
est à Paris plus variée que n'importe où dans le monde. Les grands magasins proposent aussi
véritable ; la mode extravagante se trouve dans les boutiques du Marais ; ainsi, il y en a pour toute
bourses. Par contre, celui qui aime l'art trouvera peut-être son bonheur dans les ateliers à Bellevil

En París hay numeroso edificios de lujo y de diseño moderno, y no siempre es fácil elegir. Afortu-
nadamente, la oferta para presupuestos medios y bajos también es abundante. Una alternativa a
los clásicos hoteles es alquilar una habitación en una casa particular, o pasar el fin de semana en
alguna *péniche* en la Isla de Saint-Louis en el Sena (www.paris-yacht.com). El equipamiento y el
confort en estas antiguas barcas de carga son comparables a los hoteles modernos.

A Parigi l'offerta di moda, accessori, eleganti oggetti d'arredamento, cosmetici e profumi è variegata
come forse in nessun altro luogo al mondo. Anche nei grandi magazzini è possibile trovare autenti-
co lusso, mentre per la moda alternativa ci sono le boutique di Marais, insomma ce n'è per tutte le
tasche. Gli amanti dell'arte, invece, con un po' di fortuna troveranno ottime occasioni negli atelier di
Belleville.

Left page: Palais-Royal
Right page: Left Palais-Royal, right booksellers (bouquinists) at the river bank of the Seine

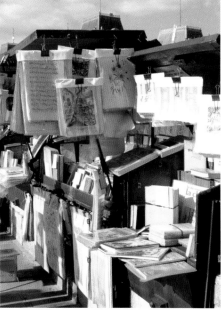

...e Jardin du Palais-Royal

Opening hours: Mon–Sat 10 am to 7 pm
Products: Primarily perfumes from Serge Lutens (Shiseido Cosmetics)
Metro station: Palais-Royal
Map: No. 56

Serge Lutens began his career in 1963 as a photographer for *Vogue*. After switching to Dior, he now works as a perfumer. The Shiseido brand and its accompanying image was his creation. He designed the business location at the Jardin du Palais-Royal in the style of a starry night. With his creations, Lutens constantly gives new impulses to the perfume industry and is now launching his own brand.

Serge Lutens commença sa carrière en 1963 comme photographe chez Vogue. Après son passage chez Dior, il travaille aujourd'hui comme parfumeur. Il créa la marque Shiseido et l'image associée. Il conçut son magasin dans le Jardin du Palais-Royal dans le style d'une nuit d'étoiles. Avec ses créations, Lutens apporte toujours un vent frais au secteur de la parfumerie et maintenant, il lance aussi sa propre marque.

La carrera de Serge Lutens comenzó en 1963 como fotógrafo en la revista Vogue. Tras pasar a Dior, hoy se ocupa de sus perfumes; él ha creado la marca y la imagen de Shiseido. Los espacios del comercio Jardin du Palais Royal están decorados al estilo de una noche estrellada. Lutens proporciona constantemente un aire nuevo al mundo de la perfumería con sus creaciones y ahora además con su propia marca.

Serge Lutens iniziò la sua carriera nel 1963, lavorando come fotografo per Vogue. Passò poi a Dior, e attualmente si occupa di profumi. Ha creato la marca e l'immagine Shiseido. Il suo negozio nel Jardin du Palais-Royal è concepito come un cielo notturno pieno di stelle. Con le sue creazioni, Lutens porta costantemente aria nuova nel settore della profumeria: come ora, con il lancio della sua marca personale.

Printemps Boulevard Haussmann

64, boulevard Haussmann
75009 Paris
9e Arrondissement
Phone: +33 / 142 82 57 87
www.printemps.com/
international

Opening hours: Mon–Sat 9.35 am to 7 pm, Thu 9.35 am to 10 pm
Products: Chic and ultra-hip designer fashion, lingerie, perfumes, coiffeur, beauty salon
Metro station: Havre - Caumartin
Map: No. 52

The historical department store established in 1865 has twice fallen victim to the flames. After the fire of 1921, the building was topped with the current magnificent dome. Already at the end of the 1920s, the department store created the Brummell brand—named after the English dandy—for ready-to-wear clothing. Ever since, there have been continuous renovations and innovations.

Ce grand magasin traditionnel, fondé en 1865, fut par deux fois la proie des flammes ; après l'incendie de 1921, le bâtiment s'est vu adjoindre sa superbe coupole. Dès la fin des années 20, le grand magasin créa la marque Brummell, du nom du dandy anglais, pour les vêtements de confection. Depuis, on rénove et innove en permanence.

Este almacén de gran tradición, fundado en el año 1865, ha sido ya dos veces víctima de las llamas. Tras el incendio de 1921, el edificio fue dotado de una imponente cúpula que aún conserva. Ya a finales de los años 20 los grandes almacenes crearon la línea de confección Brummell, así llamada por el famoso "dandy" inglés, y que desde entonces ha sido constantemente reinventada y renovada.

Fondato nel 1865 e ricco di tradizione, il magazzino è già stato devastato per due volte dalle fiamme. Dopo l'incendio del 1921, l'edificio è stato dotato della grandiosa cupola attuale. Già alla fine degli anni venti il magazzino creò la nota linea di abbigliamento Brummell, dal nome del famoso dandy inglese. Da allora, la marca è stata costantemente rinnovata e reinventata.

Galeries Lafayette

40, boulevard Haussmann
75009 Paris
9e Arrondissement
Phone: +33 / 142 82 34 56
www.galerieslafayette.com

Opening hours: Mon–Wed, Fri+Sat 9.30 am to 7.30 pm, Thu
9.30 am to 9 pm
Products: Everything from reasonably price t-shirts to exclusive
designer wear, children's clothing, toys, perfumes
Metro station: Chaussée d'Antin - La Fayette
Map: No. 21
Editor's tip: In the Lafayette Maison accross the street you will
find interior furnishing and next door menswear in the
Lafayette Homme.

The little dry goods store opened in the Rue La Fayette by the cousins Théophile Bader and Alphonse Kahn in 1893 has turned into a luxury bazaar for ladies from all social classes. The Galeries Lafayette has become the epitome of Parisian style and the latest fashion trends. The Lafayette VO shopping temple occupies an area of about 43,000 sq ft for the young and the young at heart.

La petite boutique de mercerie, ouverte en 1893 par les cousins Théophile Bader et Alphonse Kahn dans la rue La Fayette, est devenue un bazar de luxe pour les dames de toutes les couches sociales. Depuis, les Galeries Lafayette sont le symbole du chic parisien et des dernières tendances de la mode. Lafayette VO, le temple de la consommation pour les jeunes et les moins jeunes, s'étend sur 4 000 m².

De la pequeña mercería fundada en el año 1893 por los primos Théophile Bader y Alphonse Kahn en la rue Lafayette surgió un bazar de lujo para señoras de todas las clases sociales. Ahora las Galerías Lafayette son la esencia del chic parisino y de las últimas tendencias. Los 4 000 m² del templo del consumo Lafayette VO están a la disposición de jóvenes y de quienes así se sientan.

Dalla piccola merceria aperta nel 1893 in rue Lafayette dai cugini Théophile Bader e Alphonse Kahn, è nato un magazzino di lusso per signore di tutti i ceti. Da allora, le Gallerie Lafayette sono la quintessenza dello chic parigino e dell'ultima moda. Per i giovani e per coloro che si sentono tali è disponibile Lafayette VO, tempio dello shopping su 4 000 metri quadrati.

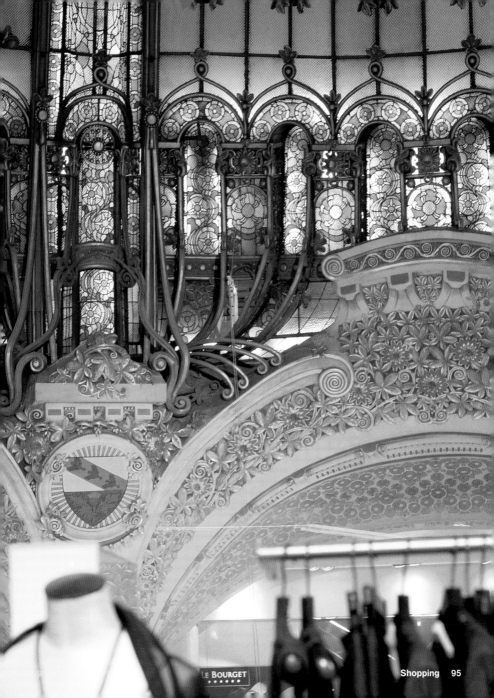

LE BOURGET

Florence Finkelsztajn

24, rue des Ecouffes,
Ecke 19, rue des Rosiers
75004 Paris
4e Arrondissement
Phone: +33 / 148 87 92 85
www.florencefinkelsztajn.free.fr

Opening hours: Sept–June daily except Wed 10 am to 7 pm,
July+Aug daily Wed–Sun 10 am to 7 pm
Products: Specialized in Yiddish, Russian and Polish pastries
Metro station: St-Paul, Hôtel de Ville
Map: No. 19
Editor's tip: You will also find homemade Pirojkis and Pletzel,
Borek and poppy seed strudel in the Jewish bakery "La Boutique
Jaune" (27, rue des Rosiers).

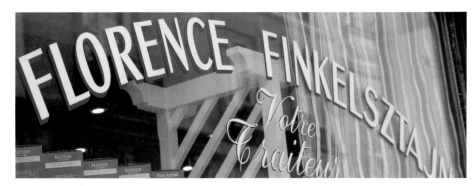

In this delicatessen with a bakery and patisserie behind a mosaic façade from the 1930s Florence Finkelsztajn celebrates the best of Jewish cuisine: delicious pastrami, gehakte fish, and schmaltz herring or—for those who like it sweet—poppyseed pastries and honey lekeh. Customers sometimes wait in long lines in front of the store.

Dans cette épicerie fine avec boulangerie et pâtisserie derrière une façade en mosaïque des années 30, Florence Finkelsztajn célèbre l'excellence de la cuisine yiddish : délicieuse viande fumée, poisson haché et hareng gras ou – pour ceux qui aiment le sucré – chausson au pavot et délice au miel. Souvent, les client font la queue devant le magasin.

En esta tienda gourmet con panadería y pastelería tras una fachada en mosaicos de los años 30 Florence Finkelsztajn hace un elogio a la cocina yiddish de lo más refinado: exquisita carne agridulce, pescado picado, arenque en sal y para los que prefieren los dulces, pasta de semillas de amapola y dulces de miel. A menudo hay que hacer cola para entrar.

In questo negozio di delicatessen con panetteria e pasticceria, dietro una facciata in mosaico degli anni trenta, Florence Finkelsztajn celebra la più raffinata cucina yiddish: squisita carne in salamoia, pesce tritato, aringa allo strutto e – per chi ama i dolci – cornetti ai semi di papavero e dolcetti al miele. Spesso c'è la coda alla porta.

Librairie Florence Loewy

9, rue de Thorigny
75003 Paris
3e Arrondissement
Phone: +33 / 144 78 98 45
www.florenceloewy.com

Opening hours: Tue–Sat 2 pm to 7 pm
Products: Specialized in arts books
Metro station: St-Paul, St-Sébastien - Froissart, Chemin Vert
Map: No. 32

Florence Loewy's book boutique in the Marais district is trying to be more of a gallery and less of a bookstore. Instead of buying books on art, this is where you can get books designed by artists and sometimes even books that cannot be read but just interpreted. They are all little works of art, and the store's extravagant interior fixtures will delight design connoisseurs.

La boutique de livres de Florence Loewys dans le Marais se veut plutôt galerie que librairie. Ici, on n'achète pas des livres sur l'art, mais des livres conçus par des artistes, parfois aussi des livres qui ne sont pas lisibles mais seulement interprétables. Ce sont tous de petits chefs d'œuvre, et l'intérieur extravagant de la boutique ravira les amateurs de design.

La librería-boutique de Florence Loewy en el Marais se está convirtiendo más y más en galería y menos en librería. Aquí no se compran libros sobre arte, sino concebidos por artistas, a veces libros no pensados para ser leídos sino interpretados. Todos ellos son obras arte contenidas en un extravagante comercio que apasiona a los aficionados al interiorismo.

La boutique del libro di Florence Loewy, nel quartiere di Marais, sta diventando sempre più galleria e sempre meno libreria. Qui non si acquistano libri che parlano di arte ma libri che sono arte, spesso anche libri che non sono tanto da leggere quanto da interpretare, dei veri piccoli capolavori. Gli originali interni del negozio entusiasmeranno gli appassionati di design.

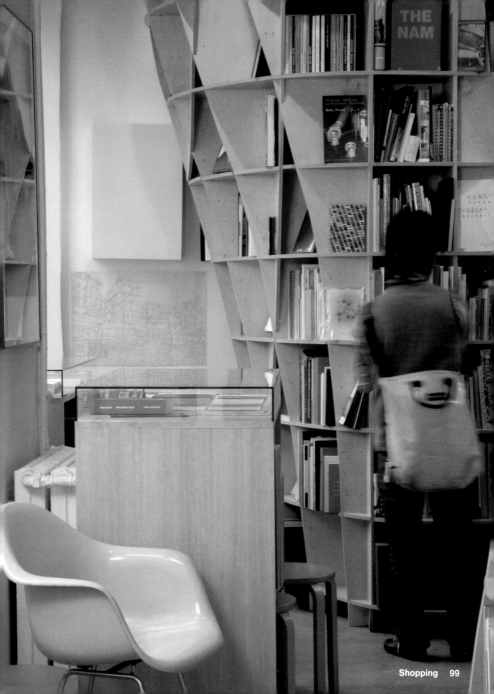

Le Bon Marché Rive Gauche

24, rue de Sèvres
75007 Paris
7e Arrondissement
Phone: +33 / 144 39 80 00
www.lebonmarche.fr

Opening hours: Mon–Wed, Fri 9.30 am to 7 pm, Thu 10 am to 9 pm, Sat 9.30 am to 8 pm
Products: Fashion, perfumes, furniture, exclusive household goods, delicatessen
Metro station: Sèvres - Babylone
Map: No. 3

Nothing is "inexpensive" in this store on the left bank of the Seine, and the name is a relic from the founding era. Today, the department store is a temple of high-end consumption, with an emphasis on quality and service. It faces the Grande Epicerie, which offers farm-fresh fruit and vegetables, a large variety of spices, exquisite delicatessen specialties, and wine.

Dans ce magasin sur la Rive Gauche, rien n'est bon marché, le nom est une relique de l'époque de sa création. Aujourd'hui, le grand magasin est un luxueux temple de la consommation, où la qualité est aussi importante que le service. La Grande Epicerie en face offre des fruits et légumes frais, une grande variété d'épices, des produits fins exclusifs et des vins.

En este comercio de la orilla izquierda del Sena "barato" no hay nada, tan sólo su nombre, recuerdo de los tiempos de su fundación. Hoy es un templo del lujo en el que Calidad y Servicio se escriben en mayúsculas. Frente a él, la Grande Épicerie ofrece frutas y verduras frescas, amplia variedad de aromas, alimentos y vino selecto.

In questo negozio sulla riva sinistra della Senna, a "buon mercato" non c'è nulla: il nome è solo un retaggio dei tempi della fondazione. Oggi il magazzino è un tempio del consumo di lusso, dalla qualità e dal servizio impeccabili. La Grande Épicerie, situata dirimpetto, offre frutta e verdura fresche, una grande varietà di aromi, cibi prelibati e vini selezionati.

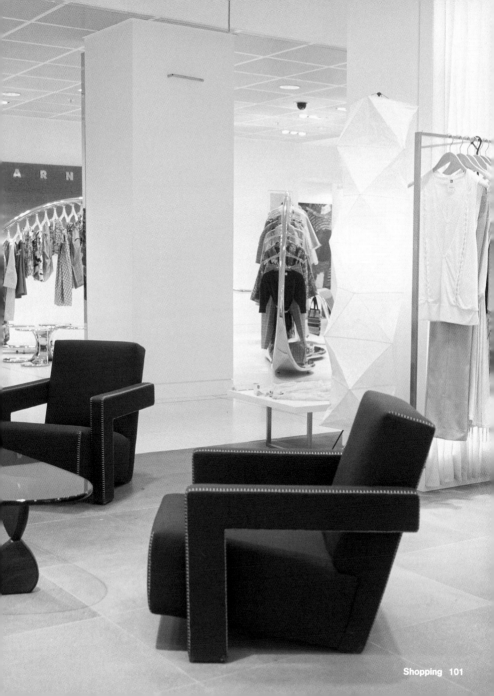

Colette

213, rue Saint-Honoré
75001 Paris
1er Arrondissement
Phone: +33 /155 35 33 90
www.colette.fr

Opening hours: Mon–Sat 11 am to 7 pm
Products: Exclusive fashion, perfumes, books; gallery, Water-bar
Metro station: Tuileries, Pyramides
Map: No. 15
Editor's tip: You can taste more than a 100 different mineral waters from all around the world in the "Water-bar" downstairs such as glacier water from Island and volcano spring water from New Zealand.

The store named after the famous writer redefines shopping by offering a smorgasbord of books, accessories, and eccentric things. The fragrance of figs hangs in the air, the music is sensual, and the fashions are extravagant. The gallery gives unknown artists and designers a chance. You can taste more than 100 different types of mineral water at the Water Bar.

Ce magasin, nommé d'après la célèbre écrivaine, redéfinit le shopping et offre un capharnaüm de livres, d'accessoires et de choses folles. Il flotte un parfum de figue, la musique est sensuelle et la mode extravagante. La galerie donne leur chance à des artistes et designers inconnus, et dans le « Water Bar », on peut goûter à plus de 100 sortes d'eau minérale.

El comercio debe su nombre a la famosa escritora y redefine el concepto del ir de tiendas ofreciendo un surtido de libros, accesorios, y objetos fuera de lo común. El aire está perfumado con aroma de higos, la música es sensual y la moda extravagante. La galería abre oportunidades a diseñadores y artistas desconocidos y en el Water Bar se sirven más de 100 variedades de agua mineral.

Il negozio, che prende il nome dalla famosa scrittrice, ridefinisce il concetto di shopping, proponendo un assortimento di libri, accessori e oggetti un po' folli. L'aria è impregnata di profumo di fico, la musica è sensuale e la moda stravagante. La galleria concede possibilità e spazio a designer e artisti sconosciuti, e nel Water Bar è possibile degustare oltre 100 tipi di acqua minerale.

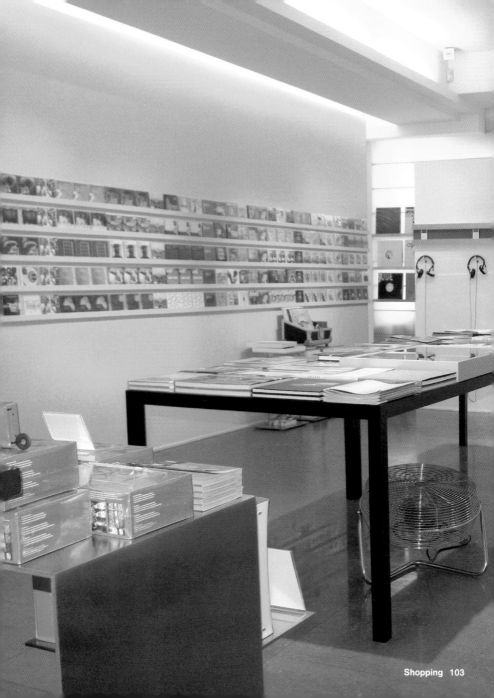

Côté Bastide

4, rue de Poissy
75005 Paris
5e Arrondissement
Phone: +33 / 156 24 01 21

Opening hours: Mon–Sat 10.30 am to 7 pm, closed on
Mon+Wed 1 pm to 2 pm
Products: Provençal interior decoration, fabrics, tableware and
everything for the bathroom
Metro station: Maubert - Mutualité, Cardinal Lemoine
Map: No. 16

This boutique offers products from the Provence that have caused a sensation throughout the entire world: Everything for the household, and fashion for the ladies. Subdued elegance in white and delicate pastel shades prevail. There are precious essences, fine table and bed linens, traditional glassware, and porcelain—a bit of Marcel Pagnol in the center of Paris.

Cette boutique offre des produits de la Provence qui font fureur dans le monde entier: tout pour le foyer et de la mode pour Madame. Il y règne une élégance discrète en blanc avec de tendres couleurs pastel. Ceci s'accompagne d'essences précieuses, de nappes, de draps, de verrerie et de porcelaine traditionnelles – un peu de Marcel Pagnol en plein Paris.

La boutique ofrece productos procedentes de Provenza que hacen furor en el mundo entero: todo para la casa y moda femenina. En el lugar reina una elegancia discreta en blanco y suaves tonos pastel. A ello se suman preciadas esencias, ropa de cama y mantelerías, cristalería y porcelanas tradicionales; un toque a la Marcel Pagnol en pleno París.

Questa boutique propone specialità provenzali apprezzate in tutto il mondo: c'è di tutto per la casa, e l'ultima moda per signora. Regna un'eleganza contenuta, in bianco e in tenui toni pastello. Vi si trovano preziose essenze, raffinata biancheria da tavola e da letto, cristalleria e porcellane tradizionali ... un tocco à la Marcel Pagnol in piena Parigi.

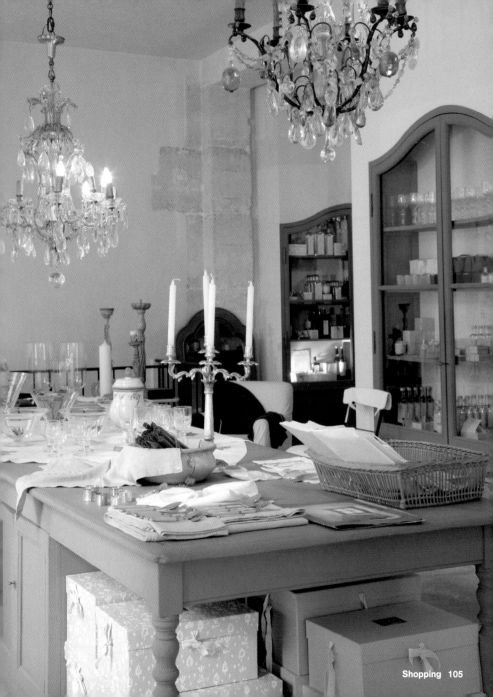

Marché aux Fleurs

Ile de la Cité
75004 Paris
4e Arrondissement
www.insecula.com

Opening hours: Daily 8 am to 7 pm
Products: Weekdays only flowers, Sundays also a bird market
Metro station: Cité
Map: No. 34

The largest flower market in Paris—the last of its kind—is located in the heart of the city. For more than 100 years, housewives have purchased their flowers here. Shoppers are now protected from the wind in summer and winter as they stroll and visit boutiques that offer exotic and carnivorous plants.

Au cœur de la ville se trouve le plus grand marché aux fleurs de Paris, le dernier de ce type. Depuis plus de 100 ans, les femmes viennent chercher leurs fleurs ici, été comme hiver, car maintenant, on peut aussi y flâner à l'abri du vent et visiter les boutiques qui offrent des végétaux exotiques et des plantes carnivores.

El mercado de flores más grande de París, el último de su clase, está ubicado en el mismo corazón de la ciudad. Desde hace más de cien años las parisinas acuden aquí para comprar sus flores, tanto en verano como en invierno, ya que ahora se puede pasear y visitar las boutiques que venden plantas carnívoras y especies exóticas resguardándose del viento.

Il principale mercato dei fiori di Parigi, ultimo del suo genere, è situato nel cuore della città. Da oltre cento anni le signore acquistano qui i loro fiori, d'estate come in inverno, visto che ora è possibile passeggiare al riparo dal vento e visitare le boutique che propongono varietà esotiche e piante carnivore.

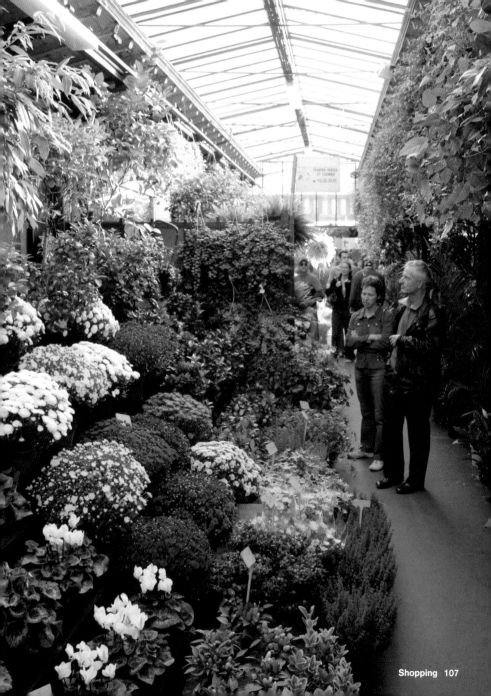

Viaduc des Arts

1–129, avenue Daumesnil
75012 Paris
12e Arrondissement
www.viaduc-des-arts.com

Opening hours: Mon–Sat 10 am to 7 pm
Products: Arts and crafts are exhibited and sold in 50 studios
Metro station: Bastille
Map: No. 59

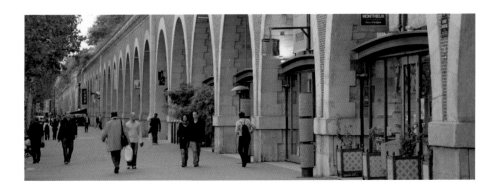

The viaduct of the railroad line between the Bastille and Vincennes, built in 1859, now serves artisans as a workshop. This is where they restore antiques, build furniture, make pottery dishes, and work with precious materials. Today, the Promenade Plantée, a footpath and bike trail, runs above the studios from the Bastille Opera to Bois de Vincennes.

Le viaduc de la voie ferrée entre Bastille et Vincennes, construit en 1859, sert aujourd'hui d'atelier à des artistes artisans. Ici, ils restaurent des antiquités, fabriquent des meubles, font de la poterie et travaillent de précieux tissus. Au-dessus des ateliers, il y a maintenant *la promenade plantée*, un chemin pour promeneurs et cyclistes, de l'Opéra Bastille au Bois de Vincennes.

El viaducto ferroviario entre la Bastilla y el Vincennes, construido en 1859, se ha convertido en lugar de trabajo para artesanos, que aquí restauran antigüedades y muebles, modelan vasos y trabajan telas preciadas. Por encima de sus "ateliers" transcurre hoy la Promenade Plantée, vía peatonal y para bicis desde la Bastilla hasta el bosque de Vincennes.

Costruito nel 1859, il viadotto ferroviario tra la Bastiglia e Vincennes funge oggi da posto di lavoro per gli artigiani: qui essi restaurano pezzi d'antiquariato, sistemano mobili, modellano vasellame e lavorano materiali preziosi. Sopra gli atelier si snoda oggi la Promenade Plantée, una via pedonale e ciclistica che va dall'Opera della Bastiglia fino al Bois de Vincennes.

-Ouen-Clignancourt

Opening hours: Sat–Mon 7 am to 7 pm
Products: Yard sale
Metro station: Porte de Clignancourt
Map: No. 53

This famous flea market has existed since 1885. It stretches over nearly 15 acres and consists of 15 different markets with a total of 2,500 boutiques, junk shops, and antique stores. In addition to high-quality arts and crafts and antiques, visitors find an abundance of secondhand clothing, as well as countless copies of brand-name articles at rock-bottom prices.

Cette fameuse brocante existe depuis 1885. S'étendant sur 6 ha, elle est constituée de 15 marchés différents et réunit 2 500 boutiques, brocantes et magasins d'antiquités. Outre des antiquités et objets d'artisanat de valeur, le visiteur y trouve des quantités de vêtements d'occasion ainsi que de nombreuses copies d'articles de marque à très bas prix.

Este célebre mercadillo existe desde 1885, ocupa más de 6 hectáreas e incluye 15 mercados distintos y unas 2 500 boutiques y tiendas de antigüedades y antiguallas. Además de obras artesanales de buen nivel, es posible encontrar cantidad de ropa de segunda mano e innumerables falsificaciones de artículos de marca a precios muy asequibles.

Questo celebre mercato delle pulci esiste fin dal 1885. Si estende su oltre sei ettari e consiste di 15 mercati diversi, comprendendo in tutto 2 500 tra boutique e negozi d'antiquariato e di anticaglie. Oltre a pezzi di antiquariato e a pregiate opere artigianali, si trovano una gran quantità di abiti di seconda mano e innumerevoli copie di articoli di marca a prezzi stracciati.

Hotels

Paris has so many luxury palaces and designer inns that it is almost impossible to make a choice. But the mid and lower price ranges also offer a great selection of accommodations. Interesting alternatives to the classic hotel are guest rooms in private houses or a weekend on a *péniche*—a former barge near Île Saint-Louis on the Seine (www.paris-yacht.com). The furnishings here can easily stand up to a comparison with those of a designer hotel.

A Paris, il y a de nombreux palaces de luxe et hôtels design, ce qui rend le choix difficile. Mais l'offre est également énorme dans les hôtels de catégorie moyenne et économique. Une nuitée en chambre d'hôte chez l'habitant ou un week-end sur une *péniche* – d'anciens chalands – sur la Seine devant l'Ile Saint-Louis (www.paris-yacht.com) constituent une alternative intéressante à l'hôtel classique. Leur aménagement n'a rien à envier à un hôtel design.

En París hay numeroso edificios de lujo y de diseño moderno, y no siempre es fácil elegir. Afortunadamente, la oferta para presupuestos medios y bajos también es abundante. Una alternativa a los clásicos hoteles es alquilar una habitación en una casa particular, o pasar el fin de semana en alguna *péniche* en la Isla de Saint-Louis en el Sena (www.paris-yacht.com). El equipamiento y el confort en estas antiguas barcas de carga son comparables a los hoteles modernos.

A Parigi ci sono numerosi edifici di lusso e alberghi dal design moderno, e non sempre è facile scegliere. Tuttavia, l'offerta è assai vasta in tutte le fasce di prezzo. Un'alternativa interessante al consueto hotel può essere una camera in affitto presso un'abitazione privata o un weekend in una *péniche* sulla Senna, davanti all'Île Saint-Louis (www.paris-yacht.com). In fatto di comodità, queste ex chiatte fluviali non hanno nulla da invidiare ai moderni hotel.

Left page: Sezz, **right page:** Left Pershing Hall, right Hôtel Le A

Le Meurice

228, rue de Rivoli
75001 Paris
1er Arrondissement
Phone: +33 / 144 58 10 10
Fax: +33 / 144 58 10 15
www.meuricehotel.com

Prices: Single from € 610, double from € 725
Facilities: Meetings rooms, spa
Services: Buffets and banquets
Metro station: Tuileries
Map: No. 36
Editor's tip: Treat yourself with an Afternoon Tea in the conservatory even though you are not a hotel guest. This is the place where Paris is exceptionally hip.

Stars are sometimes sighted in the most English of all five-star hotels in Paris, but lesser mortals with the appropriate wallet are also welcome. Le Meurice offers a romantic winter garden, trendy boutiques, and a wellness center. On the terrace of the 2,260 sq ft Belle Etoile Suite, all of Paris lies at your feet.

Dans le plus « anglais » de tous les hôtels de luxe à Paris, on voit de temps à autre des vedettes, mais le commun des mortels assez fortuné est également le bienvenu. Il y a un jardin d'hiver romantique, des boutiques branchées, une section santé-détente, et sur la terrasse de la suite Belle-Etoile, d'une surface de 210 m², tout Paris est à vos pieds.

En el más inglés de todos los hoteles de lujo de París a veces se puede ver a algún famoso, pero aquí también son bienvenidos los simples mortales que dispongan del correspondiente presupuesto. El hotel incluye un romántico jardín de invierno, boutiques de moda y un centro wellness. Desde la terraza de la suite Belle Étoile, de 210 m², París se rinde a los pies.

Nel più inglese di tutti gli hotel di lusso parigini può capitare di vedere qualche personaggio famoso, ma c'è posto anche per i comuni mortali con adeguate disponibilità economiche. Comprende un romantico giardino d'inverno, boutique di tendenza e un centro benessere; e dalla terrazza di 210 metri quadrati della suite Belle Étoile si può vedere tutta Parigi.

Murano Resort

13, boulevard du Temple
75003 Paris
3e Arrondissement
Phone: +33 / 142 71 20 00
Fax: +33 / 142 71 21 01
www.muranoresort.com

Prices: Single and double from € 350, suite from € 750,
breakfast € 20 to € 35
Facilities: Spa, parking lot
Metro station: Filles du Calvaire
City map: No. 38

Couples seeking recuperation for body and mind prefer to stay at this resort. The architecture of its façade is definitely worth seeing. The decor has a calming effect, and the beds are comfortable. The resort has a spa in which you can be pampered using every trick in the book. Some of the suites have their own private pool.

Les clients de cet hôtel à la façade architecturalement remarquable sont plutôt des couples à la recherche de repos physique et spirituel. Le décor est reposant, les lits sont confortables. Il y a également un spa avec un choix de soins spécialisés, et certaines suites ont leur propre piscine.

Tras su fachada de notable arquitectura el hotel acoge a parejas privilegiadas en busca de recuperación para el cuerpo y para el espíritu. La decoración inspira tranquilidad, las camas son muy confortables. El hotel cuenta con un centro spa para dejarse tratar a cuerpo de rey a la perfección y algunas suites incluso tienen piscina propia.

Questo hotel dalla facciata architettonicamente notevole accoglie soprattutto coppie in cerca di relax per il corpo e per la mente. L'ambiente è riposante, i letti confortevoli. Nel centro termale è possibile lasciarsi viziare a regola d'arte; alcune suite sono dotate di piscina propria.

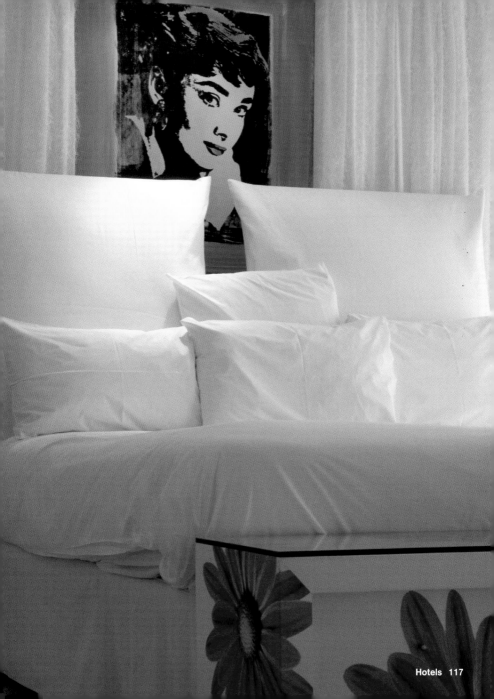

Hôtel du Petit Moulin

29/31, rue de Poitou
75003 Paris
3e Arrondissement
Phone: +33 / 142 74 10 10
Fax: +33 / 142 74 10 97
www.hoteldupetitmoulin.com

Prices: € 180 to € 350, breakfast € 15
Facilities: Private parking lot close to the hotel, free Wi-Fi, VIP shopping package
Services: Room service and massage
Metro station: Saint-Sébastien - Froissart, Filles du Calvaire
City map: No. 28

A bakery was previously housed in this building from the 17th century. Yet, Christian Lacroix has transformed it into a glitzy, many-faceted hotel. The comfortable rooms exhibit furnishings adapted from various epochs and styles—from Baroque to minimalism.

Autrefois, ce bâtiment du XVIIe siècle hébergeait une boulangerie, mais Christian Lacroix l'a transformé en un hôtel flamboyant aux multiples facettes. Les chambres confortables s'inspirent d'époques et de styles divers – du baroque au minimalisme.

El edificio del siglo XVII, que en su tiempo alojaba una panadería, se ha transformado bajo las manos de Christian Lacroix en un hotel resplandeciente y multifacético. Las cómodas habitaciones recogen elementos estilísticos de varias épocas, desde el barroco hasta el minimalismo.

L'edificio, che risale al XVII secolo, ospitava un tempo una panetteria; Christian Lacroix lo ha trasformato in uno splendido hotel dall'ambiente variegato. Le confortevoli camere sono arredate secondo le correnti stilistiche delle varie epoche, dal barocco al minimalismo.

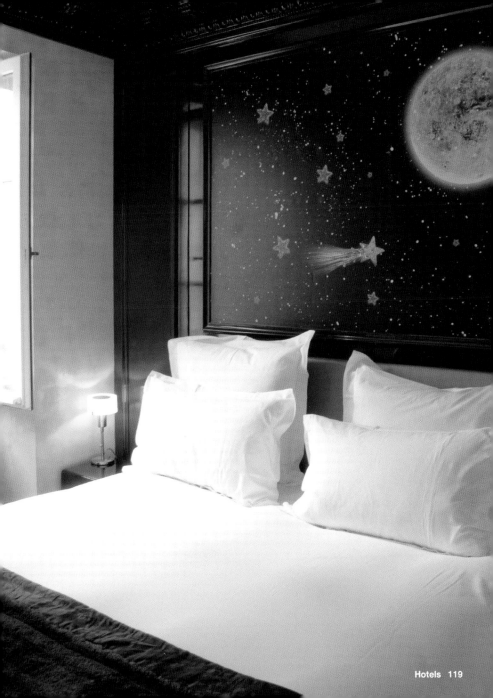

Hôtel des Grandes Ecoles

75, rue du Cardinal-Lemoine
75005 Paris
5e Arrondissement
Phone: +33 / 143 26 79 23
Fax: +33 / 143 25 28 15
www.hotel-grandes-ecoles.com

Prices: Single from € 110, double from € 135
Services: Extra bed € 20, four-bed room available, parking lot € 30
Metro station: Cardinal Lemoine, Place Monge, Jussieu
City map: No. 25
Editor's tip: The market in the Rue Mouffetard is famous for its specialities – such as oysters, truffles or raw milk cheese.

This country house with old-fashioned charm and comfort is set in a romantic garden. Floral print wallpaper from the old days decorates the walls, and the loud socializing of the Quartier Latin pervades the neighboring Rue Mouffetard. If you want to escape the hustle and bustle, the spacious garden is a perfect retreat.

Au milieu d'un jardin romantique, cette confortable maison de campagne dégage un charme désuet. Des papiers peints à fleurs d'une autre époque décorent les murs, et il règne dans la rue Mouffetard à côté, la convivialité bruyante du Quartier Latin. Ceux qui souhaitent échapper au tumulte pourront se détendre dans le jardin étendu.

Esta casa de campo con encanto y confort de sabor antiguo está ubicada en el centro de un romántico jardín. Las paredes están vestidas de un papel pintado floreado de otros tiempos mientras en la rue Mouffetard reina la ruidosa jovialidad del Barrio Latino. Para quien desee escapar del tumulto, el amplio jardín ofrece un retiro ideal.

La villa, al centro di un romantico giardino, irradia comfort e fascino d'altri tempi. Le pareti sono rivestite della carta da parati a fiorellini tipica di un tempo e nell'adiacente Rue Mouffetard regna la chiassosa giovialità del Quartiere Latino. Per chi vuole sfuggire al trambusto, l'ampio giardino offre un rifugio ideale.

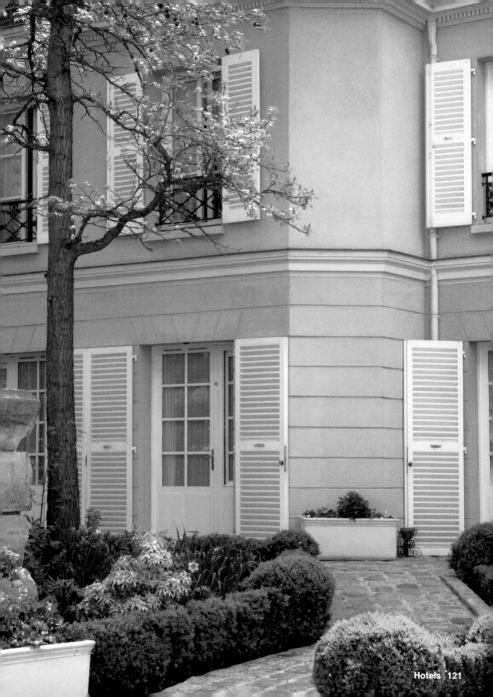

Hôtel Bel Ami

7–11, rue Saint-Benoît
75006 Paris
6e Arrondissement
Phone: +33 / 142 61 53 53
Fax: +33 / 149 27 09 33
www.hotel-bel-ami.com

Prices: Off-peak season from € 270, peak season from € 310,
junior suite from € 490, breakfast buffet € 24
Facilities: Sauna, gym and spa
Metro station: Saint-Germain-des-Prés
City map: No. 23

This chic hotel in Saint-Germain-des-Prés is housed in a former printing shop from the 18th century. The 115 double rooms and junior suites unite a cool minimalism with the greatest comfort and high-tech furnishings. Facilities include a spa with a fitness studio and massage room.

Cet hôtel chic à Saint-Germain-des-Prés se trouve dans une ancienne imprimerie du XVIIIe siècle. Les 115 chambres doubles et suites juniors combinent un minimalisme sobre avec un maximum de confort et un aménagement high-tech, sans oublier la section de remise en forme avec salle de musculation et de massage.

Este refinado hotel de Saint-Germain-des-Prés está ubicado en una antigua tipografía del siglo XVIII. Las 115 habitaciones dobles y mini-suites concilian el frío minimalismo con el máximo confort y un equipamiento de alta tecnología. Tampoco podía faltar un espacio wellness con gimnasio y sala de masajes.

Questo raffinato hotel di Saint-Germain-des-Prés si trova all'interno di un'ex tipografia del XVIII secolo. Le 115 camere doppie e Junior suite uniscono un freddo minimalismo al massimo comfort ed equipaggiamento high-tech. Non manca lo spazio riservato al benessere, con zona fitness e sala massaggi.

Hôtel Bourg Tibourg

19, rue du Bourg-Tibourg
75004 Paris
4e Arrondissement
Phone: +33 / 142 78 47 39
Fax: +33 / 140 29 07 00
www.hotelbourgtibourg.com

Prices: Single from € 160, double from € 220
Metro station: Hôtel de Ville, Rambuteau
City map: No. 24

The little hotel with just 30 rooms lies at the center of the lively Marais district. It offers exquisite elegance in a small space. The building is just as picturesque and its clientele as extravagant as the surrounding quarter. The beautiful, dreamy garden creates an oasis of peace in the middle of the hustle and bustle.

Ce petit hôtel avec seulement 30 chambres se trouve au cœur du quartier animé du Marais. Il offre une élégance exclusive dans un espace restreint. La maison est aussi pittoresque et sa clientèle aussi extravagante que le quartier alentour. Le joli jardin romantique est une oasis de calme au milieu du tumulte.

Este pequeño hotel de tan sólo 30 habitaciones está situado en el centro del movido Marais. Ofrece elegancia selecta en espacios reducidos. El edificio es tan pintoresco y la clientela tan extravagante como el barrio que le rodea. El hermoso jardín ofrece un pequeño y escondido oasis de tranquilidad.

Questo piccolo hotel, con solo 30 camere, è situato nel centro dell'animato quartiere di Marais. Offre eleganza raffinata in uno spazio ristretto. L'edificio è tanto pittoresco e la clientela tanto stravagante quanto il quartiere circostante. Il fiabesco giardino è una piccola oasi di tranquillità.

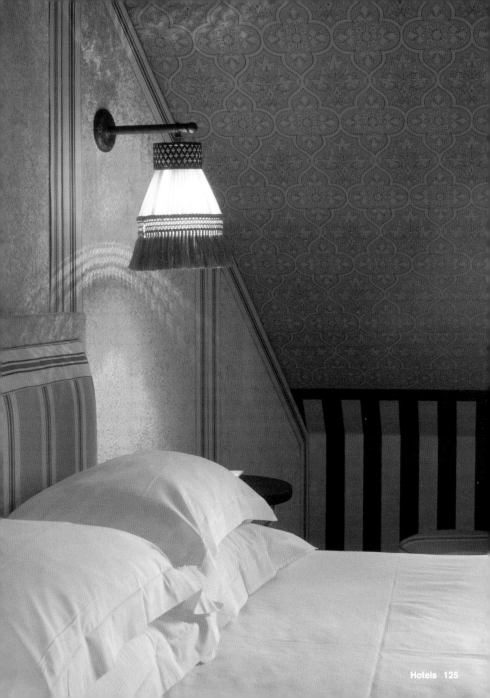

Hôtel Le A

4, rue d'Artois
75008 Paris
8e Arrondissement
Phone: + 33 / 142 56 99 99
Fax: + 33 / 142 56 99 90
www.hotel-le-a-paris.com

Prices: Single and double from € 345, junior suite from € 472,
apartment from € 620 incl. breakfast; internet booking available
Facilities: ADSL Wi-Fi, DVD + CD player, Lounge Bar, library
Services: Teatime, room service
Metro station: Saint-Philippe-du-Roule
Map: No. 27

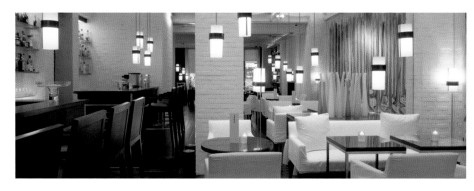

The hotel, which was originally designed as a town house, unites the solidity of the old with modern, posh furnishings. Subtle colors and geometric forms define its ambience. All of the 26 rooms and suites are individually designed. In addition to utmost comfort, they offer state-of-the-art technology.

Cet hôtel, conçu à l'origine comme une maison de ville, combine la solidité de l'ancien avec la sobriété d'une décoration moderne. Des couleurs discrètes et des formes géométriques créent l'ambiance. Les 26 chambres et suites sont toutes individualisées et offrent un confort extrême et une technologie ultramoderne.

Concebido en origen como edificio residencial, este hotel integra la pureza de lo antiguo con una soberbia decoración moderna. El ambiente está definido por colores discretos y formas geométricas. Las 26 habitaciones están decoradas de forma individual y, además de confort, todas ofrecen la más moderna tecnología.

Concepito in origine come palazzo residenziale, questo hotel integra la solidità dell'antico con un raffinato arredamento moderno. Colori tenui e forme geometriche definiscono l'ambiente. Tutte le 26 camere e suite sono arredate in modo individuale e offrono massimo comfort e tecnologia moderna.

Sezz

6, avenue Frémiet
75016 Paris
16e Arrondissement
Phone: +33 / 156 75 26 26
Fax: +33 / 156 75 26 16
mail@hotelsezz.com
www.hotelsezz.com

Prices: Single from € 270, double from € 320, suite from € 535
Facilities: Spa, conference room, free Wi-Fi
Services: Welcome drink
Metro station: Passy
Map: No. 57

A personal "assistant" welcomes guests in the elegant lobby. The hotel with its 27 rooms and 14 suites is fascinating with its classy design and professional service. Its spacious accommodations are a special luxury. The wellness area invites guests to relax.

Un « assistant » ou une « assistante » accueille personnellement les hôtes dans un foyer élégant. L'hôtel, avec ses 27 chambres et 14 suites, séduit par un design noble et un service professionnel. L'étendue des espaces est un luxe particulier. La section de remise en forme vous invite à la détente.

Un "asistente" o "asistenta" personal dan la bienvenida a los huéspedes en el elegante salón. El hotel de 27 habitaciones y 14 suites seduce por su diseño distinguido, la profesionalidad de su servicio y con el privilegio de contar con grandes estancias. El wellness además invita al relax.

Un assistente personale dà il benvenuto all'ospite nella elegante lobby. Dotato di 27 camere e 14 suite, l'hotel ci seduce con il suo design raffinato e la professionalità del servizio. La vastità dei vani conferisce un lusso particolare. L'area benessere ci invita al relax.

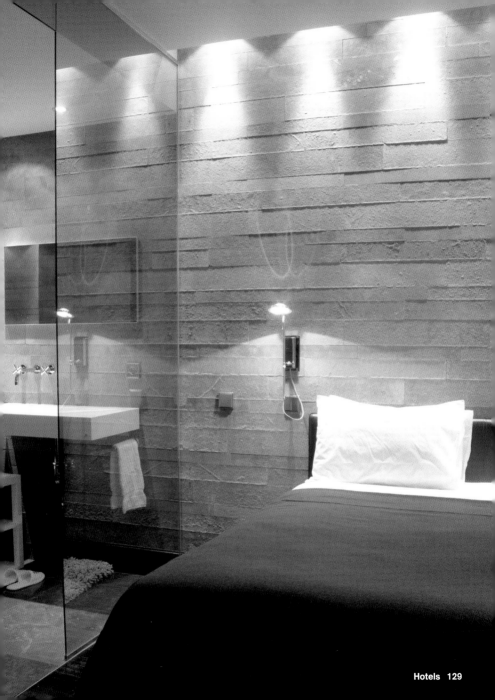

Le Dokhan's

Sofitel Demeure Hotels
117, rue Lauriston
75116 Paris
16e Arrondissement
Phone: +33 / 153 65 66 99
Fax: +33 / 153 65 66 88
www.dokhans-sofitel-paris.com

Prices: Single from € 440, double from € 460, suite € 850
Facilities: Garage, free Wi-Fi, Jacuzzi
Metro station: Trocadéro
Map: No. 17

The neoclassical corner building that houses Le Dokhan's is typical for the modernization of the city in the 19th century by Baron Haussmann. With its 41 rooms and 4 suites, the hotel radiates classical elegance. The champagne bar is the only one in the city that also serves light meals.

Le bâtiment classique à l'angle d'une rue, qui héberge Le Dokhan's, est typique de la modernisation de la ville au XIXe siècle sous le baron Haussmann. Cet hôtel, avec ses 41 chambres et 4 suites, offre une élégance classique. Le bar-champagne est le seul de la ville à servir également des repas légers.

La construcción en estilo neoclásico que acoge el hotel es un ejemplo típico de la modernización que vivió la ciudad en el siglo XIX, de la mano del Barón de Haussmann. El hotel cuenta con 41 habitaciones y 4 suites, todas de elegancia clásica. El "bar de champagne" es el único de París que sirve comidas ligeras.

L'edificio d'angolo in stile neoclassico che ospita l'hotel è un tipico esempio della modernizzazione della città, operata nel XIX secolo sotto l'amministrazione del Barone Haussmann. L'hotel comprende 41 camere e 4 suite di eleganza classica. Lo champagne bar, unico in città, serve anche pasti leggeri.

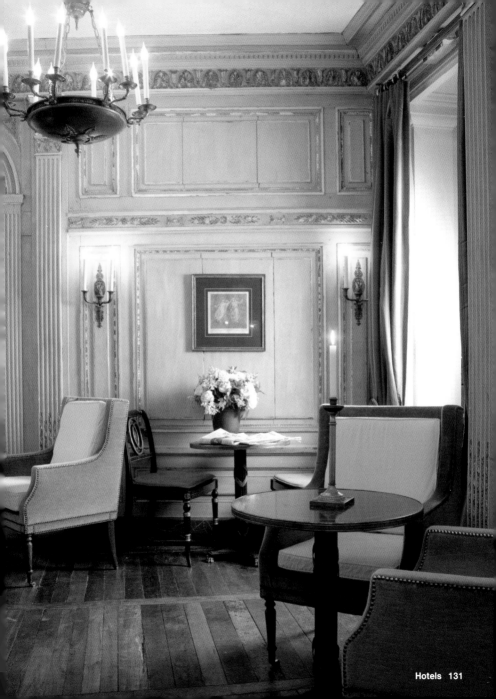

Kube

1–5, passage Ruelle
75018 Paris
18e Arrondissement
Phone: +33 / 142 05 20 00
Fax: +33 / 142 05 21 01
www.kubehotel.com

Prices: Single € 250, double € 300, double "KUBE" € 400, junior suite € 500, suite € 750
Facilities: Gym, Ice Kube-Bar Tue 7 pm to 8 pm and Wed–Sat 7 pm to 2 am only with reservation
Metro station: La Chapelle
Map: No. 31

This is a mecca for design fans: There are cubes everywhere you look. The reception desk is located in a glass cube. Some of the 41 rooms have fluorescent stools or nightstands that look like ice cubes. Only the shell chairs in the bar are not cubic. The Ice Cube bar serves vodka at 23 °F.

La Mecque pour les fans de design : il y a des cubes partout, où que l'on regarde. La réception est logée dans un cube en verre ; dans certaines des 41 chambres, il y a des tabourets ou des tables de nuit fluorescents qui ressemblent à des cubes de glace. Seuls les fauteuils-coques du bar ne sont pas cubiques. Dans le « Ice Kube-Bar », on sert de la vodka par moins 5 degrés.

Un sueño para los aficionados al diseño: hay cubos por donde quiera que se mire. La recepción está instalada en un cubo de cristal, en algunas de las 41 habitaciones hay taburetes o mesitas fluorescentes, que parecen cubos de hielo. Los únicos objetos no cúbicos son los sillones del bar. En el bar "Ice Cube" se sirve vodka a cinco grados bajo cero.

Una Mecca per gli appassionati di design: ci sono cubi ovunque si guardi. La reception si trova in un cubo di vetro, in alcune delle 41 camere ci sono sgabelli o comodini fluorescenti che sembrano grossi cubetti di ghiaccio. Gli unici oggetti non cubici sono le sedie del bar. Nel bar "Ice Cube" si sorseggia vodka a cinque gradi sotto zero.

What else?

There are many sights to see even away from the Louvre, the Eiffel Tower, and Montmartre: For example, the Saint-Martin canal, the lively artist and immigrant quarter of Belleville, or the suburbs with their multicultural inhabitants. Whether you relax in Bois de Boulogne, bike, or stroll along the Seine: Aspects of everyday life, places off the beaten track, and forgotten quarters are often worth seeing. Discovering Paris also means rediscovering it!

En dehors du Louvre, de la Tour Eiffel et de Montmartre, il y a beaucoup à voir : par exemple, le canal Saint-Martin, le quartier animé des artistes et des immigrés de Belleville ou les banlieues avec leur population multiculturelle. Que vous vous détendiez au Bois de Boulogne, à vélo ou en flânant au bord de la Seine : ce sont souvent les choses quotidiennes, des endroits à l'écart ou des quartiers oubliés qui sont intéressants. Car découvrir Paris, c'est aussi le redécouvrir encore et toujours !

Aparte del Louvre, la Torre Eiffel y Montmartre hay mucho más que ver: el canal Saint-Martin, por ejemplo, el palpitante barrio étnico artístico de Belleville, o los barrios periféricos multiculturales. Ya sea relajarse en el Bois de Boulogne, pasear o andar en bicicleta junto al Sena, lo interesante es con frecuencia disfrutar de los placeres cotidianos, recorrer barrios olvidados y lugares alejados del turismo masificado. París es descubrir y redescubrir.

Anche non considerando il Louvre, la Torre Eiffel e Montmartre, c'è molto da vedere, come il canale Saint-Martin, il palpitante quartiere etnico-artistico di Belleville, oppure i sobborghi, abitati da gente di tutte le culture. Rilassandoci nel Bois de Boulogne, andando in bicicletta o passeggiando lungo la Senna, possiamo apprezzare le cose di tutti i giorni, quartieri dimenticati, posti fuori mano ... è così che possiamo davvero scoprire Parigi!

Left page: Jardin du Luxembourg, **right page:** Left Jardin du Palais-Royal, right Parc André Citroën

Jardin du Palais-Royal

Place du Palais-Royal
Rue de Valois
75001 Paris
1er Arrondissement
Phone: +33 / 147 03 92 16
www.paris.fr

Opening hours: Daily 7.30 am to 8.30 pm
Metro station: Palais-Royal
Map: No. 30
Editor's tip: This area is famous for its historic arcades dating back to the early 19th century. Worth mentioning is the gallery Véro-Dodat with its beautiful old-fashioned "Café de l'Epoque".

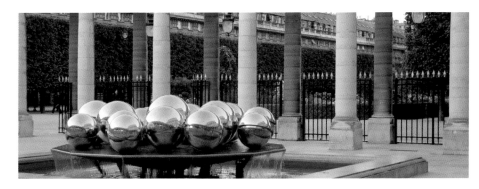

The writer Colette, as well as other famous residents of the quarter, had a wonderful view of the Palais-Royal garden from her residence. The Louvre des Antiquaires, with its 250 galleries displaying art treasures from various epochs, is now located directly next to the oasis of almost 5 acres.

De son domicile, l'écrivaine Colette avait une vue superbe sur le Jardin du Palais-Royal, comme d'autres habitants connus de ce quartier. Juste à côté de cette oasis de 2 ha se trouve aujourd'hui le Louvre des Antiquaires, où 250 galeries montrent des trésors d'art de toutes les époques.

Desde su casa la escritora Colette gozaba de una fabulosa vista al jardín del Palacio Real, al igual que otros famosos habitantes del barrio. Al lado de este oasis de paz de dos hectáreas de extensión se encuentra el Louvre de los Anticuarios, donde 250 galerías exponen obras de todas las épocas.

Da casa sua, la scrittrice Colette godeva di una vista favolosa sul giardino del Palais Royal, così come altri celebri abitanti del quartiere. Di fianco a quest'oasi di pace, estesa su due ettari, si trova oggi il Louvre des Antiquaires, nel quale 250 gallerie espongono lavori artistici di ogni epoca.

bourg

Opening hours: Daily 7.30 am to 9.45 pm (summer), 8.15 am to 4.45 pm (winter)
Metro station: Notre-Dame-des-Champs
Map: No. 29

This park in the style of French garden architecture is famous for its numerous fountains and statues. It is a favorite meeting place for students, but children also take delight in the garden's diverse forms of entertainment and the popular carousel. In addition, there are various recreational opportunities such as tennis, boule, and chess.

Ce parc comprenant des jardins à la française est connu pour ses nombreuses fontaines et statues. C'est le rendez-vous de prédilection des étudiants, mais les enfants aiment aussi les diverses attractions et le fameux manège. En outre, il y a différentes activités de loisir comme le tennis, la pétanque et les échecs.

Este parque en el estilo francés de arquitectura de jardín es famoso por sus numerosas estatuas y fuentes. Si bien es muy popular como punto de encuentro para estudiantes, los niños también se divierten en el solicitado carrusel y otras tantas atracciones. A ello se unen diversos pasatiempos como el tenis, los bolos o el ajedrez.

Questo parco dal tipico stile architettonico francese è famoso per le numerose fontane e statue che lo adornano. È molto popolare come luogo di ritrovo per gli studenti, ma la giostra e gli altri giochi attirano anche i bambini. Diverse aree sono poi attrezzate per passatempi quali tennis, bocce e scacchi.

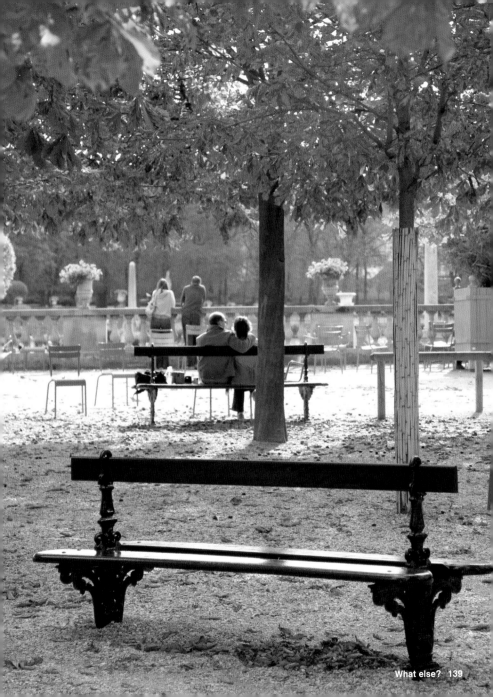

Parc André Citroën

Quai André-Citroën
Rue Balard
75015 Paris
15e Arrondissement
Phone: +33 / 144 26 20 00
www.aeroparis.com
www.paris.fr

Opening hours: Park 9 am to 6 pm (closure hours according to season); balloon closes 30 min. before the park closure
Prices: Balloon ride (depending on the weather) Mon–Fri children 3–11 years € 5, children (11 and over) € 9, adults € 10, Sat+Sun children 3–11 years 6 €, children (11 and over) € 10, adults € 12
Metro station: Balard
Map: No. 50

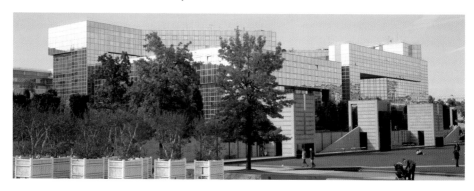

A marvelous park has been created on the former plant premises of Citroën. The *Jardin en mouvement* is just as charming as the gardens of metamorphosis, the appearance of which changes with the seasons. You can get a view of the entire area from a giant captive balloon anchored to the ground with a rope.

Un parc magnifique a été aménagé sur le terrain de l'ancienne usine Citroën. Le *jardin en mouvement* est aussi séduisant que le *jardin des métamorphoses*, dont l'aspect varie avec les saisons. D'un énorme ballon captif, retenu au sol par un câble, on peut admirer tout le site.

El antiguo recinto de la fábrica Citroën está ocupado hoy por un hermoso parque. El Jardín en Movimiento es tan encantador como el Jardín de las Metamorfosis, cuyo aspecto varía según la época de año. Desde un gigantesco globo amarrado al suelo se puede divisar todo el recinto.

Sul terreno che ospitava la sede della fabbrica Citroën è sorto un magnifico parco. Altrettanto affascinanti sono il Giardino in Movimento e il Giardino della Metamorfosi, il cui aspetto varia a seconda della stagione. Da un gigantesco pallone fissato al suolo è possibile ammirare l'intera area.

CinéAqua

2, avenue des Nations-Unies
75016 Paris
16e Arrondissement
Phone: +33 / 140 69 23 23
ventes@cineaqua.fr
www.cineaqua.com

Opening hours: Mon–Sun 10 am to 8 pm
Admission: Adults € 19.50, teenagers (13–17 years) and students € 15.50, children € 12.50
Metro station: Trocadéro
Map: No. 12

You can watch sharks feed and stroke carp and sturgeon in this fascinating underwater landscape. The old aquarium has been renovated to create an audio-visual adventure world with 43 freshwater and saltwater pools, video walls, and movie theaters. Even concerts take place here. Don't feed the sharks!

Dans ce fascinant paysage sous-marin, vous pouvez observer des requins en train de manger, toucher des carpes et des esturgeons. L'ancien aquarium s'est transformé en un monde d'attractions audiovisuelles avec 43 bassins d'eau douce ou salée, des écrans vidéo et des cinémas. On y donne même des concerts. Interdiction de nourrir les requins !

En este encantador paisaje submarino se pueden observar directamente los tiburones comiendo y acariciar carpas y esturiones. El antiguo acuario se ha transformado en una nueva experiencia audiovisual, con 43 piscinas de agua dulce y salada, pantallas en las paredes, cines e incluso conciertos. ¡Prohibido dar de comer a los tiburones!

In questo affascinante paesaggio sottomarino si possono osservare gli squali mentre mangiano, e accarezzare carpe e storioni. Il vecchio acquario è stato ristrutturato in una nuova esperienza audiovisiva con 43 vasche d'acqua dolce e salata, maxischermi e cinema. Vi si tengono anche dei concerti. È vietato dar da mangiare agli squali!

Bois de Boulogne

Bois de Boulogne
75016 Paris
16e Arrondissement
www.paris.fr

Metro station: Porte Maillot, Avenue Foch
Map: No. 2
Editor's tip: The Jardin d'Acclimatation is a kind of an amusement park in which the little Paris visitors can have fun – there is a mini zoo, a carrousel, miniature golf and even donkey rides.

Baron Haussmann had the former hunting grounds of the kings transformed into a park in English style during the mid-19th century and opened it to the public. People like to stroll and bike here. There are picturesque lakes, various restaurants, two race tracks, and the famous Roland-Garros tennis stadium.

Au milieu du XIXe siècle, le baron Haussmann fit transformer cet ancien terrain de chasse des rois en un parc à l'anglaise et l'a ouvert au public. Il est apprécié des randonneurs et des cyclistes. Ici, il y a des lacs pittoresques, divers restaurants, deux champs de course et le fameux stade de tennis Roland Garros.

A mediados del siglo XIX el barón de Haussmann hizo transformar el antiguo coto de caza real en un parque de estilo inglés y lo abrió al público. La zona está muy frecuentada, especialmente para dar paseos a pie o en bicicleta e incluye pintorescos estanques, varios restaurantes, dos hipódromos y el célebre estadio de tenis Roland Garros.

A metà del secolo XIX il barone Haussmann fece trasformare l'ex riserva di caccia reale in un parco in stile inglese e ne aprì l'accesso al pubblico. È un luogo ideale per passeggiate a piedi o in bicicletta, tra pittoreschi laghetti, vari ristoranti, due ippodromi e il celebre stadio per il tennis Roland Garros.

Moulin Rouge

Montmartre
82, boulevard de Clichy
75018 Paris
18e Arrondissement
Phone: +33 / 153 09 82 82
www.moulin-rouge.com

Prices: Performance at 9 pm € 99, at 11 pm € 89, dinner at 7 pm followed by the performance at 9 pm from € 145; reservation: fax +33 / 142 23 02 00 and internet
Metro station: Blanche
Map: No. 37

 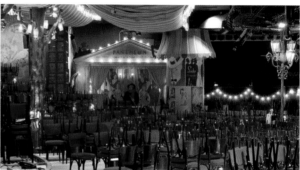

The name of the most famous cabaret in the world immediately conjures up well-known paintings by Toulouse-Lautrec, wickedness and sin. For some time, the attraction of the house has been an aquarium in which naked beauties splashed around. Similar to Les Folies Bergère, the city's oldest vaudeville theater, tourists remain on their own here.

Le nom du plus célèbre cabaret au monde évoque tout de suite les fameux tableaux de Toulouse-Lautrec, la luxure et le péché. Pendant un temps, l'attraction de la maison était un aquarium, dans lequel s'ébattaient des beautés nues. Comme aux Folies Bergère, le plus ancien cabaret de la ville, les touristes restent entre eux.

El nombre del más famoso cabaret del mundo evoca las ilustraciones de Toulouse-Lautrec, la extravagancia y el pecado. Una de las atracciones de la casa solía ser un acuario en el que luchaban bellezas desnudas. Junto al Folies Bergère, el más antiguo teatro de variedades de la ciudad, el Moulin Rouge sigue siendo uno de los lugares favoritos de los turistas.

Il nome del cabaret più famoso del mondo evoca istantaneamente i celebri quadri di Toulouse-Lautrec, la stravaganza e il peccato. Una delle attrazioni della casa era un acquario in cui nuotavano bellissime donne nude. Rimane uno dei luoghi di ritrovo preferiti dai turisti, così come le Folies Bergère, il più antico teatro di varietà della città.

Cimetière du Père Lachaise

16, rue du Repos
75020 Paris
20e Arrondissement
www.pere-lachaise.com

Opening hours: 16th March to 5th Nov Mon–Fri 8 am to 5.30 pm,
Sat 8.30 am to 5.30 pm, 6th Nov to 15th March Mon–Fri 8 am to
6 pm, Sat 8.30 am to 6 pm, Sun and on legal holidays 9 am to
5.30 pm (6 pm)
Metro station: Gambetta, Père Lachaise, Philippe Auguste
Map: No. 11
Editor's tip: You can see real bones in these Parisian catacombs
(Metro 2 to place Denfert-Rochereau). Not suitable for cowards
or little children!

When the most beautiful cemetery in the world was opened in 1804, it was situated far outside the city and designed as an English landscape garden. Since then, many famous personalities—including Balzac, Chopin, Oscar Wilde, Marcel Proust, Edith Piaf, and Jim Morrison—have found their final resting place at the parklike grounds.

Quand le plus beau cimetière du monde ouvrit ses portes en 1804, il se situait loin en dehors de la ville et était aménagé en jardin à l'anglaise. Depuis lors, de nombreuses personnalités connues y ont trouvé leur dernier repos, dont Balzac, Chopin, Oscar Wilde, Marcel Proust, Edith Piaf et Jim Morrison.

Cuando se abrió, en el año 1804, el camposanto más bonito del mundo se encontraba entonces fuera de la ciudad y tenía la apariencia de un paisaje inglés. Desde entonces el parque ha sido lugar de reposo de numerosas personalidades, entre ellos Balzac, Chopin, Oscar Wilde, Marcel Proust, Edith Piaf y Jim Morrison.

Alla sua apertura nel 1804, il più bel camposanto del mondo si trovava molto al di fuori della città ed era allestito come un giardino all'inglese. Da allora, in quest'area simile ad un parco, hanno trovato l'ultimo riposo personaggi famosi come Balzac, Chopin, Oscar Wilde, Marcel Proust, Edith Piaf e Jim Morrison.

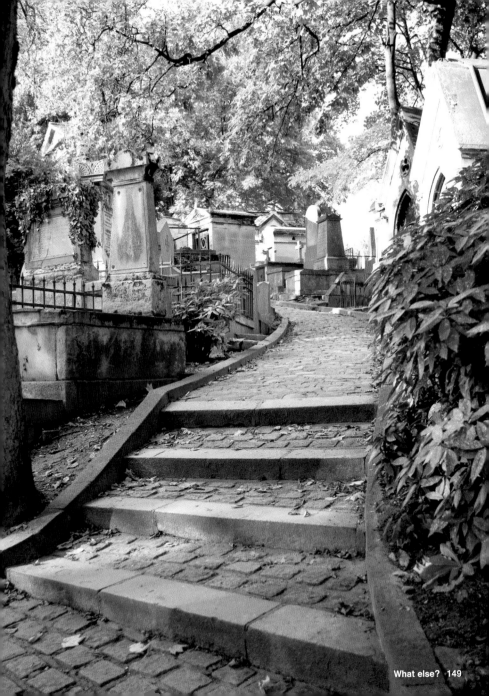

ARRIVAL IN PARIS

By Plane

There are two international airports in the city area. Information:
Phone: +33 / 39 50 www.aeroportsdeparis.fr

Paris Charles de Gaulle (CDG)

Situated 25 km (5.5 miles) north of downtown Paris. With RER trains line B from Terminal 1 and 2, departing every 10–15 mins, via Gare du Nord to Châtelet-Les Halles station in the city center, traveling time approx. 30 mins. With Roissybus from Terminal 1, 2 and 3, departing every 15–20 mins to Opéra station, traveling time approx. 45–60 mins. With Air France coaches e.g. every 12 mins to Arc de Triomphe, traveling time 40 mins (www.cars airfrance.com). A cab ride to downtown Paris costs approx. € 50 (extra charge of approx. 15 % from 7 pm to 7 am and on weekends).

Paris Orly (ORY)

Situated approx. 16 km (10 miles) south of the city center. With RER line Orlyval departing every 4–7 mins to Antony station, then changing to RER line B to Châtelet-Les Halles station in the center, traveling time approx. 35 mins. With shuttle buses departing every 15 mins to RER station Pont de Rungis, then change to RER line C to Gare d'Austerlitz, traveling time approx. 35 mins. With Orlybus departing every 15–20 mins to RER station Denfert-Rochereau and then changing to RER line B to Châtelet-Les Halles in the city center, traveling time approx. 40 mins. With Air France coaches departing every 15 mins via Gare Montparnasse to the Invalides station, traveling time approx. 60 mins (www.cars airfrance.com). A cab ride to downtown Paris costs approx. € 35

and takes about 70 mins (extra charge of approx. 15 % from 7 pm to 7 am and on weekends).

By Train

There are six **terminal stations** in Paris: Gare St-Lazare, Gare du Nord, Gare de l'Est, Gare de Lyon, Gare d'Austerlitz and Gare Montparnasse, depending from which direction you are traveling from. All terminal stations have direct access to the Metro or the RER.

Further Railway Information

SNCF: Phone: +33 / 836 35 35 35, www.sncf.fr
Thalys: www.thalys.com

Immigration and Customs Regulations

European citizens need a valid identity card for traveling to France. For EU citizens there are virtually no custom regulations. Every person at the age of 17 or older is allowed to carry goods for personal needs duty-free, e.g. 800 cigarettes, 400 cigarillos, 200 cigars, 1 kg of tobacco, 10 l of liquor, 90 l of wine and 110 l of beer.

INFORMATION

Tourist Information

Office du Tourisme de Paris

25, rue des Pyramides
75001 Paris
Phone: +33 / 892 68 30 00
www.parisinfo.com
June–Oct opened daily from 9 am to 7 pm, Nov–May, Mon–Sat 10 am to 7 pm, Sun 11 am to 7 pm
Amongst others there are offices at the Gare du Nord station, at Carrousel du Louvre and at Place du Tertre in Montmartre.

City Magazines

Every Wednesday the event calendars **Pariscope** and **L'Officiel des Spectacles** with information on movies, theaters and concerts as well as exhibition schedules and opening hours are published. The monthly magazine **Time Out** as well as the gastronomy guide **Time Out Eating & Drinking** are published in English.

Websites

General
www.parisinfo.com – Website of the Paris Tourist Information (EN)
www.paris.fr – Official website of the city (FR, EN)

Going Out
www.eatinparis.com – Online restaurant guide (FR, EN)
www.parissi.com – Concerts, exhibitions, restaurants, bars and clubs (FR)
www.parisvoice.com – Scene guide with tips from the editorial staff and calendar of events (EN)
www.timeout.com/paris – Restaurants and bars, shopping, nightlife, calendar of events (EN)

Art and Culture
www.legeniedelabastille.net – Artists and galleries in the Bastille district (FR)
www.monum.fr – Presentation of national architectural monuments, e.g. Notre-Dame, Arc de Triomphe, Sainte-Chapelle, Panthéon (FR, EN)
www.parisbalades.com – Virtual walk through Paris with detailed information on the districts and architectural monuments (FR)
www.paris-pittoresque.com – The historical Paris with ancient pictures and engravings (FR)
www.picturalissime.com – Overview over Parisian museums with links (FR, EN)
www.theatreonline.com – Theater guide (FR)

Sports and Leisure
www.bercy.fr – Sports calendar and opening hours of the ice rink in the Palais Omnisports Paris-Bercy (FR)
www.boisdevincennes.com – Leisure activities in the large Bois de Vincennes park (FR)
www.disneylandparis.com – Website of the famous amusement park (EN)
www.pari-roller.com – Exploring Paris on in-line skates, every Fri night for advanced skaters, every Sun afternoon for beginners (FR, EN)

Map
www.hot-maps.de – Interactive city map (D, EN)

Accommodation
www.all-paris-apartments.com – Accommodations in Paris (EN)
www.parishotels.com – Hotel search engine and online reservations (FR, EN)
www.paris-apts.com – Reservation of apartments (EN)
www.rentapart.com – Reservation of apartments (FR, EN)

Event Calendar
www.sortiraparis.com – Event calendar with booking service and annotated addresses (FR)

RECOMMENDED LITERATURE

Ernest Hemingway
A Moveable Feast. After World War I, Hemingway came to Paris as a newspaper correspondent. His memories take the reader to the Paris of the Twenties.

Victor Hugo
The Hunchback of Notre Dame. The tragic story of the hunchbacked, one-eyed Quasimodo and the beautiful Esmeralda takes places in medieval Paris around the Notre-Dame

cathedral. In the third book, Hugo describes "A Bird's-eye View of Paris".

Gaston Leroux
The Phantom of the Opera. Terrible things happen in the Paris Opera. But who is responsible? The eerie love story was later used by Andrew Lloyd Webber for his famous musical.

Guy de Maupassant
Bel-Ami. Driven by extreme ambition and selfishness, the journalist Georges Duroy climbs his ladder to success – a brilliant portrayal of the corrupt press and finance business at the end of the 19th century.

Daniel Pennac
The Scapegoat / The Fairy Gunmother / Monsieur Malaussène / Write to Kill (and others). The Malaussène clan lives in the Parisian immigrant district Belleville. Benjamin, the oldest of the children, is constantly involved into peculiar crimes. As a born scapegoat he is always the main suspect.

Raymond Queneau
Zazie in the Metro. The precocious and rebellious country girl Zazie spends a weekend in Paris with her uncle Gabriel.

Georges Simenon
Maigret ... The famous pipe-smoking detective investigates in Paris in more than 60 crime novels. The investigations take him to the Paris of the ordinary people and into the nocturnal demimonde.

Andrea Weiss
Paris was a Woman. A richly illustrated portrait of the "Parisian women of the Rive Gauche", implying artists and authors like Colette, Gertrude Stein and Djuna Barnes.

Emile Zola
Le Ventre de Paris. After having fled from a prison camp, Florent lives with his brother Quenu and his wife Lisa – a detailed study of the Parisian district Les Halles.

CITY TOURS

Sightseeing Tours by Bus

Sightseeing buses
Several agencies offer guided city tours, thematic tours and trips, lasting from 1.5 hrs up to 1 day, from € 17.50/pers. There are open-topped double-decker buses circulating in the city center every 10–30 mins with the possibility to interrupt the tour at any tourist attraction, day ticket € 25/pers., two-day ticket € 28/pers.
Cityrama, 149, rue Saint-Honoré, Phone: +33 / 144 55 61 00, www.cityrama.com
Les Cars Rouges, 17, quai de Grenelle, Phone: +33 /153 95 39 53, www.carsrouges.com
Paris l'OpenTour, 13, rue Auber, Phone: +33 / 142 66 56 56, www.paris-opentour.com
Paris Vision, 214, rue de Rivoli, Phone: +33 / 142 60 30 01, www.parisvision.com

Balabus
During the summer months on Sun, the municipal bus line Balabus serves the main sites between Gare du Lyon and Grande Arche de la Défense with the option to interrupt the tour at any tourist attraction. April–Sept, Sun 1.30 pm to 8.30 pm (last departure from Gare du Lyon), departing every 15–30 mins, duration approx. 70 mins, www.ratp.fr

Bicycle Tours
Guided half and full day bicycle tours as well as tours in the evening are organized regularly by:
Paris à Vélo c'est sympa, 22, rue Alphonse-

Baudin, Phone: +33 / 148 87 60 01, www.
parisvelosympa.com
Paris-Vélo, 2, rue du Fer à Moulin, Phone: +33 /
143 37 59 22, www.paris-velo-rent-a-bike.fr

Boat Tours

Seine Tours
Many of the attractions are situated along the
bank of the Seine River and the most comfort-
able way to see them is by boat. Besides guided
cruises of about an hour (departing every 30–
40 mins, approx. € 9/pers.), there are also
special offers like dinner and musical tours. The
piers are situated near the Eiffel Tower (Pont
d'Iéna), at Pont de l'Alma and in front of Notre-
Dame, depending on the company.
Bateaux Parisiens, Phone: +33 / 825 01 01 01,
www.bateauxparisiens.com
Compagnie des Bateaux Mouches, Phone: +33
/142 25 96 10, www.bateauxmouches.com
Vedettes de Paris, Phone: +33 / 144 18 19 50,
www.vedettesdeparis.com

Batobus
www.batobus.com
Eight stops between Eiffel Tower and Jardin
des Plantes are approached by the river buses,
departing every 30 mins. Day ticket € 11/pers.,
two-day ticket € 13/pers., five-day ticket € 16/
pers.

Channel Tours
Boat tours on the Canal Saint-Martin are not
that well-known, but nevertheless very
interesting. With Canauxrama departing every
day at 9.45 am and 14.30 pm from Port de
l'Arsenal to Parc de la Villette and vice versa,
duration approx. 2.5 hrs, € 14/pers. Combined
Seine-Channel-Cruise with Paris Canal, from
the end of March until mid-Nov, departing

every day at 9.30 am from Musée d'Orsay and
at 2.30 pm from Parc de la Villette, duration
approx. 3 hrs, € 16/pers.
Canauxrama, Phone: +33 / 142 39 15 00,
www.canauxrama.com
Paris Canal, Phone: +33 / 142 40 96 97,
www.pariscanal.com

Guided City Tours

Paris Balades
www.parisbalades.com
Tours through Paris with certified tourist
guides. The website gives an overview of the
program and the organizing companies.

Lookouts

A view over the roofs of Paris is always
fascinating. The best opportunity therefore,
without a doubt, still is the **Eiffel Tower** with
its viewing platform at 276 m. Another very
absorbing panorama can be seen from the
roof terrace of the **Maine-Montparnasse
Tower** at a height of 206 m. The view from the
110 m high **Grande Arche** is a little bit
disappointing due to the distance between
the monument and the city center. Other
popular lower lookouts are **Notre-Dame, Arc
de Triomphe, Pompidou Center, Panthéon,
Institut du Monde Arabe** as well as the
department stores **Samaritaine** and **Print-
emps**, all offering an excellent view over Paris.
The view from the **Sacré-Coeur** on the
Montmartre hill is popular, too. A breathtaking
way to overview the city is a balloon ride in
the safely fixed **Ballon de Paris** in the Parc
André Citroën (www.aeroparis.com).

TICKETS & DISCOUNTS

Ticket Offices

FranceBillet
Phone: +33 / 892 69 21 92
http://otparis.francebillet.com
Online ticket service or via phone.

Fnac
Bastille, 4, place de la Bastille, Mon–Sat 10 am to 8 pm
Champs-Elysées, 74, avenue des Champs-Elysées, Mon–Sat 10 am to midnight, Sun 11 am to midnight
Forum des Halles, 1–7, rue Pierre-Lescot, Mon–Sat 10 am to 7.30 pm. Tickets for every kind of event.

Check Théâtre
33, Rue le Peletier, Phone: +33 / 142 46 72 40, www.check-theatre.com
Phone service Mon–Sat 10 am to 7 pm
Tickets for theater, opera, and concerts.

Kiosque Théâtre
Madeleine, 15, place de la Madeleine
Tour Montparnasse, Esplanade de la Tour Montparnasse. Tue–Sat 12.30 pm to 8 pm, Sun until 4 pm, sale of reduced-price tickets for theater, opera and concerts with performances on the same day.

Discounts

Paris Museum Passport
Free entry without waiting time to more than 60 museums and monuments in Paris and the surrounding areas. Available at the Office du Tourisme and the participating museums, as well as online at www.parisinfo.com. Two-day ticket € 30, four-day ticket € 45, six-day ticket € 60, www.parismuseumpass.fr.

Paris Visite
Free rides with RER, Metro, and buses as well as reduced entry fees for several sights. Available from one up to five days and for three, five or eight zones. The pass is on sale in every Metro station, as well as online at www.parisinfo.com. Day ticket for 1–3 zones € 8.50, www.ratp.fr.

GETTING AROUND IN PARIS

Local Public Transport

RATP – Transports en Île-de-France
Phone: +33 / 892 68 77 14
www.ratp.fr
The fastest and cheapest means of transport in Paris is the Metro, operating 16 lines from 5.30 am to 1 am. The Metro system is connected to five RER lines (A – E), which are serving the suburbs and the airports. Metro and RER (Réseau Express Régional) are completed by a dense bus network as well as streetcar lines in the outskirts. 42 night bus lines (noctilien) guarantee the transport for night revelers. The transport network is divided into zones. The purple ticket for 1–2 zones is valid for rides within the urban area and for the whole Metro network. The maximum duration of a ride in Metro with a single ticket is 2 hours with no changing restrictions, while the single ticket for the bus (ticket has to be canceled upon boarding!!!) is valid for one ride only without changing. Keep the tickets until the end of the ride, sometimes they are needed to open the exit gates. Single ticket 1–2 zones € 1.40, ticket for ten rides (carnet) € 10.90. Unlimited riding with

the day ticket Mobilis, 1–2 zones € 5.50 and Paris Visite (see above). Tickets on sale in every Metro station and in labeled shops, single tickets can be purchased from the bus driver. Route maps are available for download or interactive use on the website of the RATP.

Cabs

Alpha Taxi, Phone: +33 / 145 85 85 85
Taxis Bleus, Phone: +33 / 819 70 10 10
Taxis G7, Phone: +33 / 147 39 47 39
There are 3 different cab rates:
A (Mon–Sat 10 am to 5 pm within the urban area),
B (Mon–Sat 5 pm to 10 am, Sun 7 am to midnight within the urban area, every day 7 am to 7 pm outskirts and airports),
C (all other times and in the surrounding areas).
Minimum rate € 5.20, extra charge for more than two pieces of baggage and for rides from or to rail stations or airports.

FESTIVALS & EVENTS

This is just an excerpt from the program for the year.

Festival du Film des Femmes

At the end of March, International Women's Film Festival at the Maison des Arts de Créteil (www.filmsdefemmes.com).

Banlieues Bleues

At the beginning of March until the beginning of April, Jazz and world music festival in the northeastern suburbs (www.banlieuesbleues.org).

Foire du Trône

April/May, large funfair in the Bois de Vincennes (www.foiredutrone.com).

Fête de la Musique

21st June, Open air concerts of diverse genres (classical music, Jazz and Rock, world music, etc.) in the parks, squares and streets (www.fetedelamusique.culture.fr).

Course de Garçons de Café

At the end of June, race of the waiters and waitresses in working clothes and with a full tray. Starting and finishing point of the 8 km (5 miles) track is the Hôtel de Ville.

Fête Nationale

14th July, the evening before the national holiday there are public balls, processions and fireworks, on the 14th there is a huge military parade on the Champs-Elysées (www.14-juillet.cityvox.com).

Paris, Quartier d'Été

Mid July–end of Aug, comprehensive cultural program during the summer holidays with music, circus, dance, and theater.

Tour de France

At the end of July, finish of the famous cycle race on the Champs-Elysées (www.letour.fr).

Journées du Patrimoine

Mid Sept, open day in historical and public buildings (www.jp.culture.fr).

Festival d'Automne

Mid Sept–mid Dec, music, theater, and movie festival on several Parisian stages (www.festival-automne.com).

Nuit Blanche

At the beginning of Oct, a night full of cultural events.

USEFUL NOTES

Money
National currency: Euro (€)
Bank and credit cards: Money can be withdrawn at cash machines with Maestro-Card and other common credit cards and many hotels, restaurants, and shops accept credit cards.

Emergency
Police: Phone: 17
Ambulance (SAMU): Phone: 15
Fire Department: Phone: 18

Opening hours
Banks: Mon–Fri 9 am to 5 pm, some banks close during midday from 12.30 pm to 2 pm.
Shops: Normally Mon–Sat from 9 am to 7 pm, supermarkets usually longer. Smaller shops close during midday and on Mon. Bakers and butchers open on Sun mornings.
Museums: Usually from 9/10 am to 5/6 pm, one day in the week until 9/10 pm. Closing day is mostly Mon or Tue, smaller museums close during midday.
Restaurants: Lunch from noon until 1.30 pm, dinner approx. 8 pm to 10.30 pm.

Costs & Money
Paris is one of the most expensive metropolises of the world. One night in a simple hotel for two persons in a double-bed room (without breakfast) costs approx. € 100. A three course menu for lunch costs approx. € 20 and for dinner € 30. The prices for a coffee, a soft drink or a beer are between € 4 and 5.

Smoking
It is prohibited to smoke in public buildings, Metro stations and public means of transport. Restaurants und cafés are obligated to have a separate non-smoking area.

When to go
Paris is worth a trip (visit) at every time of the year. During winter, temperatures hardly fall below the freezing point, although there is plenty of rain during Jan and Feb. During the French summer vacations in July and Aug the city is not that hectic, because many locals leave the town. But during midsummer some restaurants go on vacation too. The best months for visiting Paris are May, June and Sept.

Security
Paris does not differ much from other European cities; the normal precautions have to be taken. At night, remote and poorly lit areas have to be avoided. Tourists should be aware of pickpockets in the Metro, in stations and at flea markets.

Phone Calls
Dialing code Paris: In France the dialing code forms part of the ten-digit phone number and is always marked, even in local calls.
Calling from abroad: +33 + desired phone number without 0
Calling from Paris: country code + area code without 0 + desired phone number
Directory assistance: Phone: 12
Public telephone boxes work with telephone or credit cards. The telephone cards can be purchased in kiosks or tobacco stores.

Tipping
Service and taxes are included in all prices. In hotels, restaurants, or cabs, satisfied clients can tip 5–10 % of the charged amount.

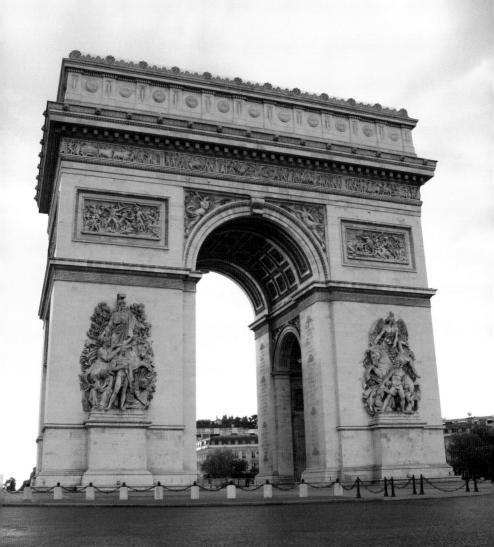

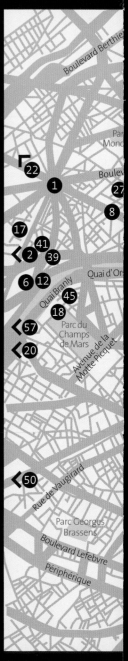

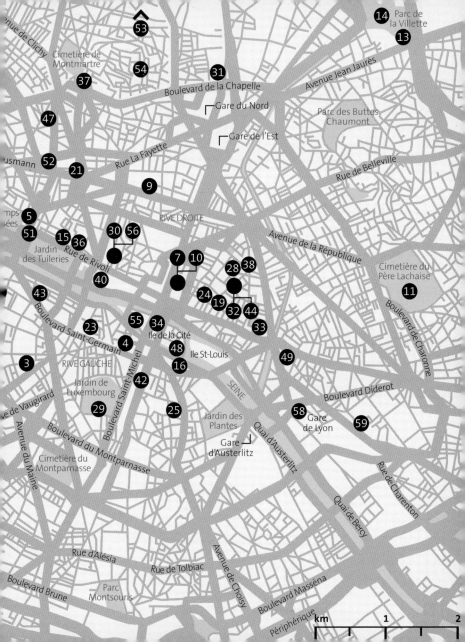

City Highlights INTERNATIONAL EDITION

BARCELONA
ISBN 978-3-8327-9192-6

LONDON
ISBN 978-3-8327-9194-0

NEW YORK
ISBN 978-3-8327-9193-3

PARIS
ISBN 978-3-8327-9195-7

Size: 15 x 19 cm / 6 x 7 ½ in.
160 pp., Flexicover
c. 300 color photographs
Text in English, French, Spanish and Italian
€ 14.90 $ 18.95 £ 9.95 Can.$ 25.95 SFR 27.50

teNeues